✓ W9-BYV-671 Bom **Newark Public Library** 121 High Street Newark, NY 14513 www.newark.pls-net.org 315-331-4370 Items not returned by the latest date stamped will be charged a per-day late charge. Please make note of your item's date due. Check online or call to renew. 0 4 AUG 2009 SFP 1 4 2009 JUN 27 2011 13 OCT

NEWARK PUBLIC LIBRARY 121 HIGH ST. NEWARK, NY 14513

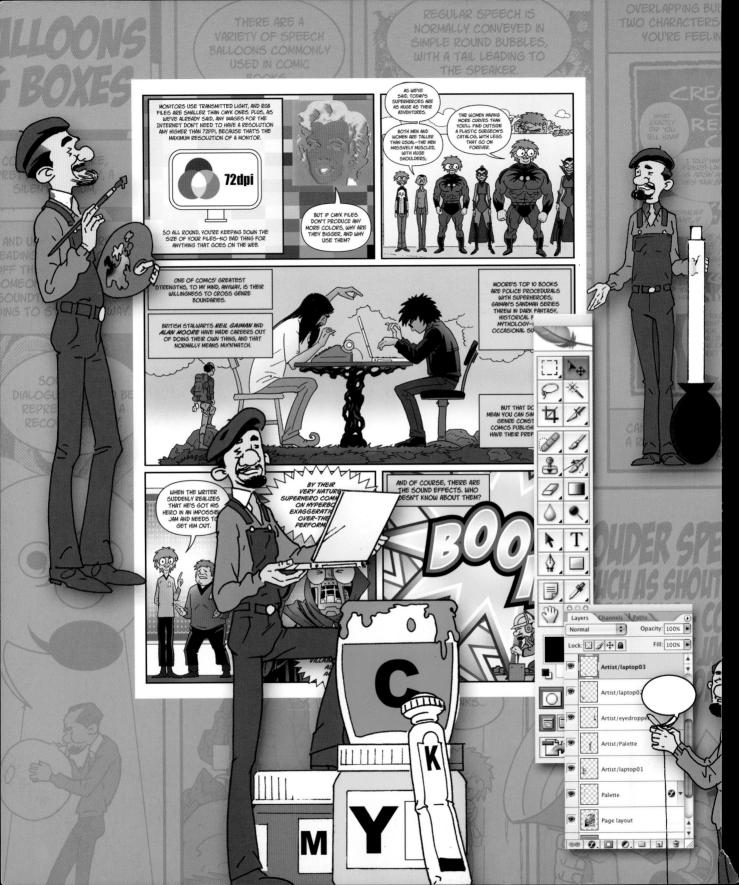

GEERE COLOCED GEERE COLOCED USING PIGITAL TECHNIQUES

MIKE CHINN AND CHRIS MCLOUGHLIN

BARRON'S

ULTRA-VIOLENT, ULTRA-NOIR, WHERE MEN ARE TOUGHER ANI

First edition for the United States, its territories and dependencies and Canada published in 2007 by Barron's Educational Series, Inc.

Text © copyright 2007 by The Ilex Press Limited Design © copyright 2007 by The Ilex Press Limited

This book was conceived, designed, and produced by The Ilex Press Limited.

All rights reserved. No part of this book may be reproduced in any form, by photostat, microfilm, xerography, or any other means, or incorporated into any information retrieval system, either electronic or mechanical, without the written permission of the copyright owner.

All inquiries should be addressed to: Barron's Educational Series, Inc. 250 Wireless Blvd. Hauppauge, NY 11788 www.barronseduc.com

ISBN-13: 0-978-7641-3465-4 ISBN-10: 0-7641-3465-5

Library of Congress Control No.: 2006930325

For more information on this title please visit: www.web-linked.com/grnous

Printed and bound in China

987654321

Every effort has been made to credit the artists and/or copyright holders whose work has been reproduced in this book. We apologize for any omissions, which will be corrected in future editions. All Marvel comic book characters and Marvel comic book material featured herein: ™ & © 2006 Marvel Characters, Inc. Used with permission.

CONTENTS

HELLO AND WELCOME	8
FROM PULPS TO E-ZINES	0

1) SO WHAT IS A GRAPHIC NOVEL? 12

GRAPHIC NOVELS VERSUS COMIC BOOKS14
GENRES AND BEYOND16
SCIENCE FICTION18
10RROR 20
FANTASY22
CRIME + ADULT
MANGA
S THERE ANYTHING LEFT?
EXAMPLES IN PRINT 30

5 UP IN ARMS. JUST AS

2) STRUCTURES AND ELEMENTS	32
TERMINOLOGY	. 34
FRAMES OR PANELS?	. 36
CONSTRUCTING A STORYLINE	. 38
BALLOONS + BOXES	.40
CHARACTERIZATION	42

3) COMPUTERS AS CREATORS

44

QUICK REFERENCE
WORKING ONLINE
WORD-CRUNCHING
DRAWING WITH SOFTWARE
COLORING
SAVING
PUBLISHING: PRINT OR WEB?

A HARD, BRUTAL RECREATION OF LIFE IN DEPRESSION-STRUCK AMERICA OGERS AND FLASH SORDON FELL INTO THAT CATEGORY DESCENT OF THOSE OLD PULP STORIES,

4) IPEAS FIRST	60
INSPIRATION	62
OBSERVING PEOPLE	64
KEEPING NOTES AND RECORDS	66
DIGITAL CAMERAS	68

5) GETTING THE SCRIPT WRITTEN

WRITING STYLES
ONLINE COLLABORATION
PACE
CHARACTER DEVELOPMENT
SETTING
USE OF MOVIE TECHNIQUES
RESEARCH
WRITING A BRIEF AND SYNOPSIS

6) GETTING THE SCRIPT PRAWN

ARTISTIC STYLES 92
ARTISTS' TECHNIQUES
BITMAP AND VECTOR SOFTWARE
MAC OR PC?
WORKING FROM A BRIEF 100
WORKING FROM A SCRIPT102
MOOD 104
STYLES OF ARTWORK
PANEL LAYOUTS 108
FRAMING DEVICES AND CROPS 110
SCANNING IN HAND-DRAWN ARTWORK
USE OF LAYERS 114
RGB OR CMYK? 116
CREATING BALLOONS AND LETTERING
PLACING TYPOGRAPHY120

7) 30 OR NOT 30?

O

0

70

90

122

THE NEXT BIG THING?124	ł
SKETCHING IN 3D126	,
CREATING SOLID BACKGROUNDS	
REALISTIC CHARACTERS)

INDERLYING THEMES ARE CONFLI

8) PHBLISH AND BE PAZZLED

132

WEB COMICS
FLASH!
SELF-PUBLISHING
PROMOTION AND MARKETING 140
THE INTERNET FOR SALES AND PROMOTION 142
BASIC NETWORKING144
PITCHING TO A PUBLISHER

RESOURCES

148

BOOKS	150
ORGANIZATIONS + JOURNALS	.152
ONLINE RESOURCES	.154
GLOSSARY	.156
INDEX	.158
ACKNOWLEDGMENTS	.160

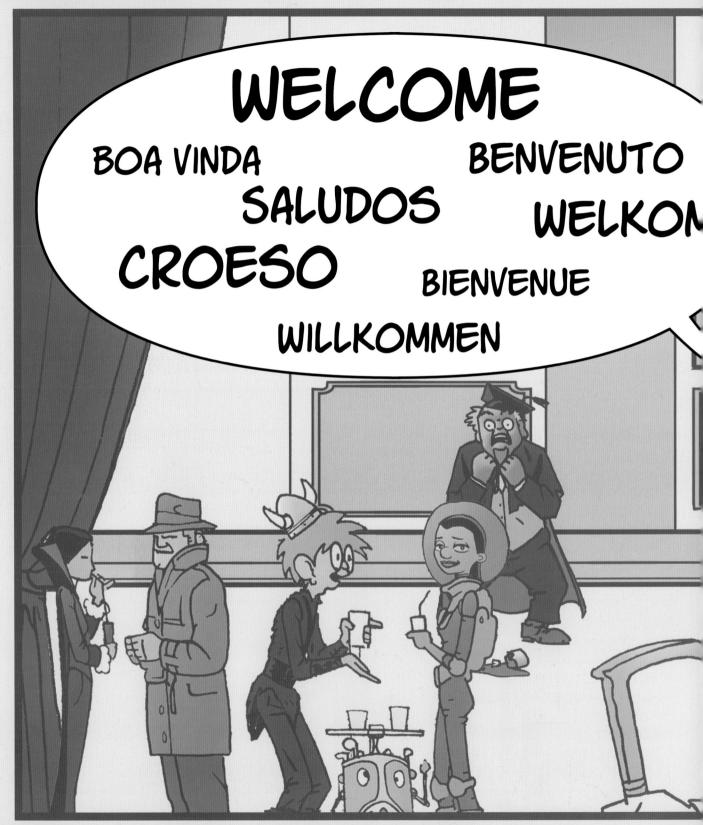

INTRODUCTION

HELLO AND WELCOME	•	 	•	• •	 •	•	 •	•	•	8	3
FROM PULPS TO E-ZINES	• • •	 	•	• •		•	 •	•	•	10	c

HELLO AND WELCOME

...TO THE COLLEGE OF THE COMIC ARTS. I HOPE YOU'LL ENJOY YOUR STAY. MY NAME IS FRANKLIN EISNER, AND I AM THE PROFESSOR OF GRAPHIC NOVEL STUDIES AND SEQUENTIAL ART HERE AT THE COLLEGE. WITH THE HELP OF FOUR OF MY COURSE STUDENTS-YUMI, KEVIN, NAVINDER, AND JONATHAN-I'LL BE INTRODUCING YOU TO THE WORLD OF GRAPHIC NOVELS. WE'LL START WITH A DEFINITION OF WHAT THEY ARE, AND THEN RUN THROUGH THE MOST POPULAR STYLES AND GENRES, BEFORE MOVING ON TO INFORMATION ON CREATING YOUR OWN COMICS AND GRAPHIC NOVELS.

WHETHER YOU'RE A COMICS FAN, A CARTOONIST, A SCRIPTWRITER, OR EVEN A FILMMAKER, YOU'LL FIND SOMETHING HERE TO INTEREST, ENLIGHTEN, AND ENTERTAIN YOU. THE GRAPHIC NOVEL IS AN EXPANDING MEDIUM, AND ONE THAT IS RAPIDLY GAINING A WIDER AUDIENCE AS MORE MOVIE ADAPTATIONS ARE MADE AND AWARENESS IS RAISED. THERE'S NEVER BEEN A BETTER TIME TO GET INTO GRAPHIC NOVELS. WELCOME ABOARD.

INTROPLICTION

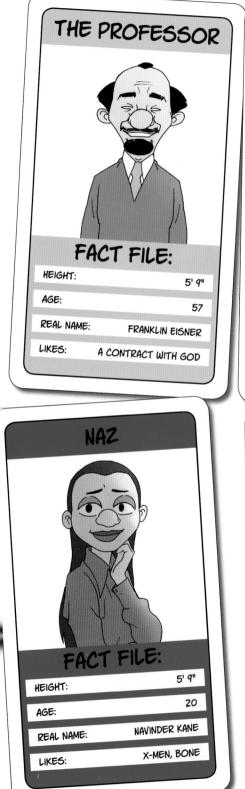

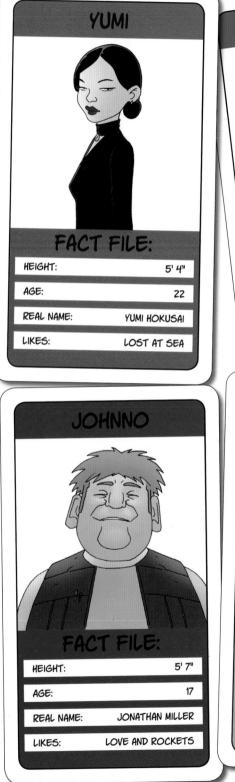

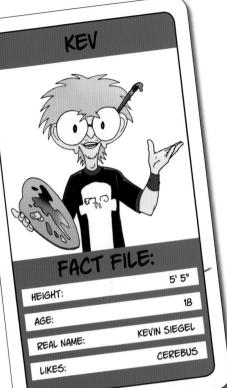

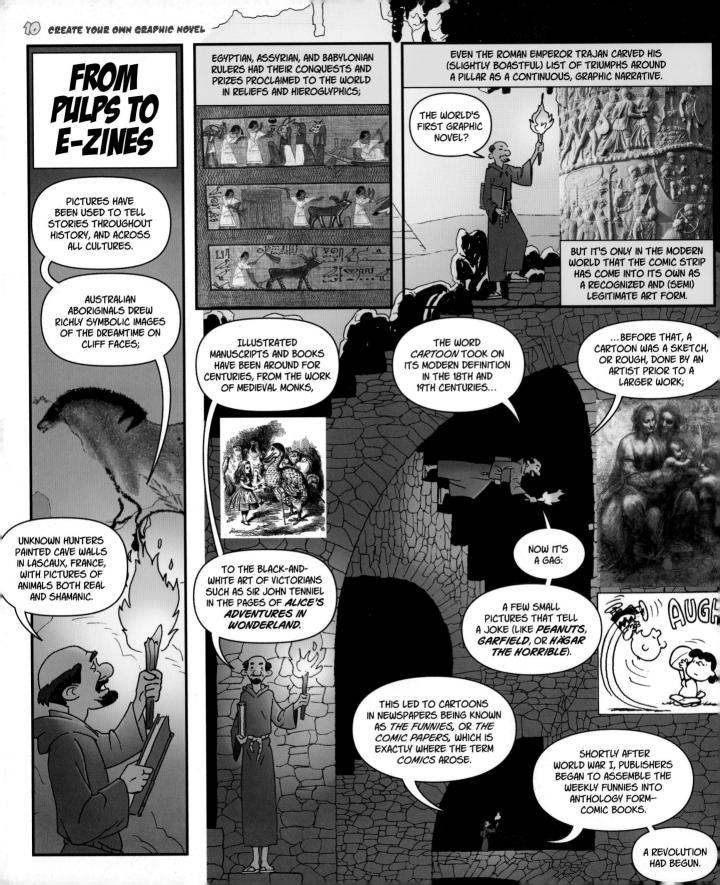

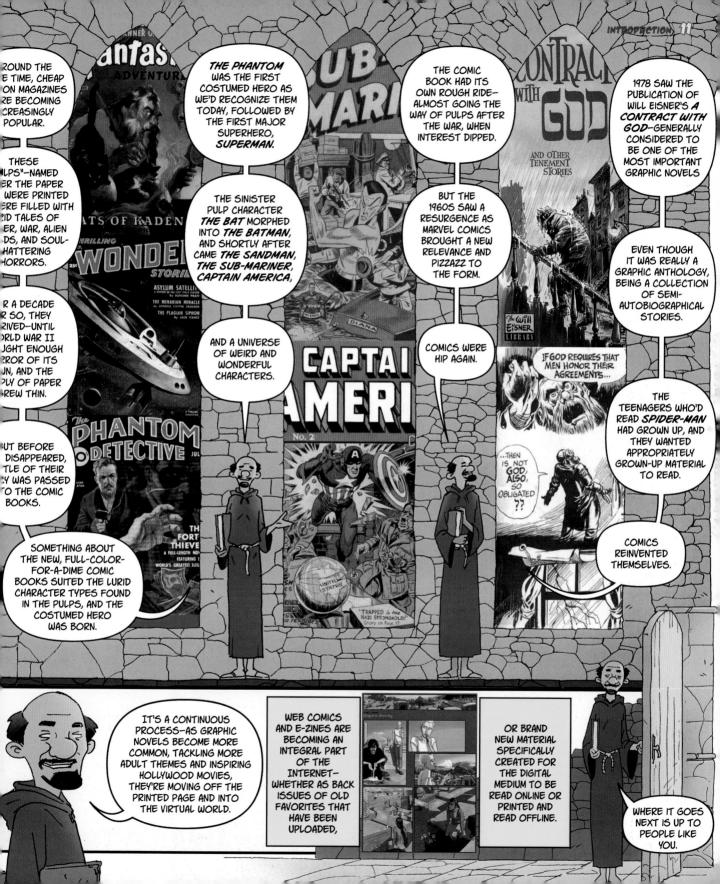

CHAPTER 1

GRAPHIC NOVELS VERSUS COMIC BOOKS 14
GENRES AND BEYOND16
SCIENCE FICTION
HORROR 20
FANTASY 22
CRIME + ADULT
MANGA
IS THERE ANYTHING LEFT?
EXAMPLES IN PRINT

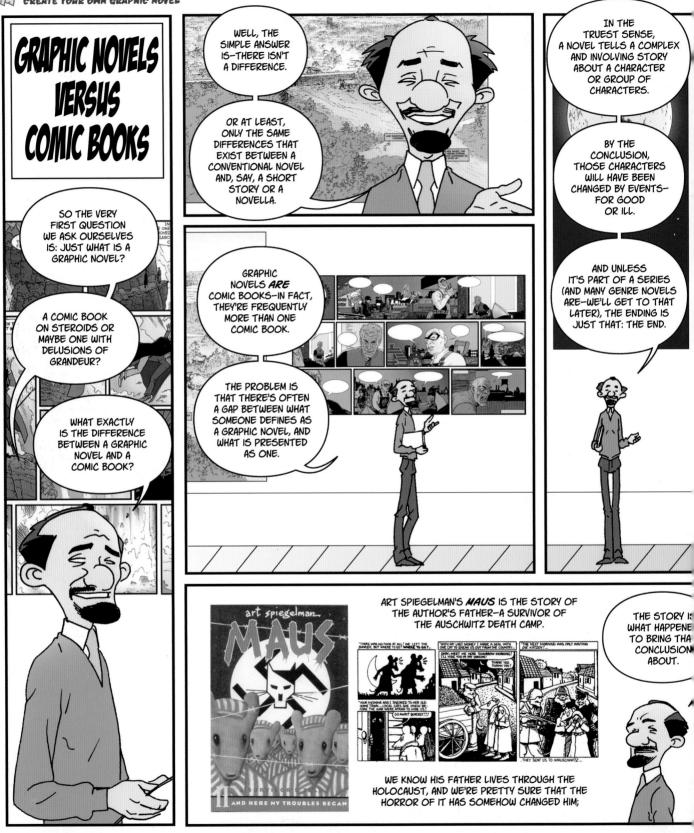

SO WHAT IS A GRAPHIC NOVEL?

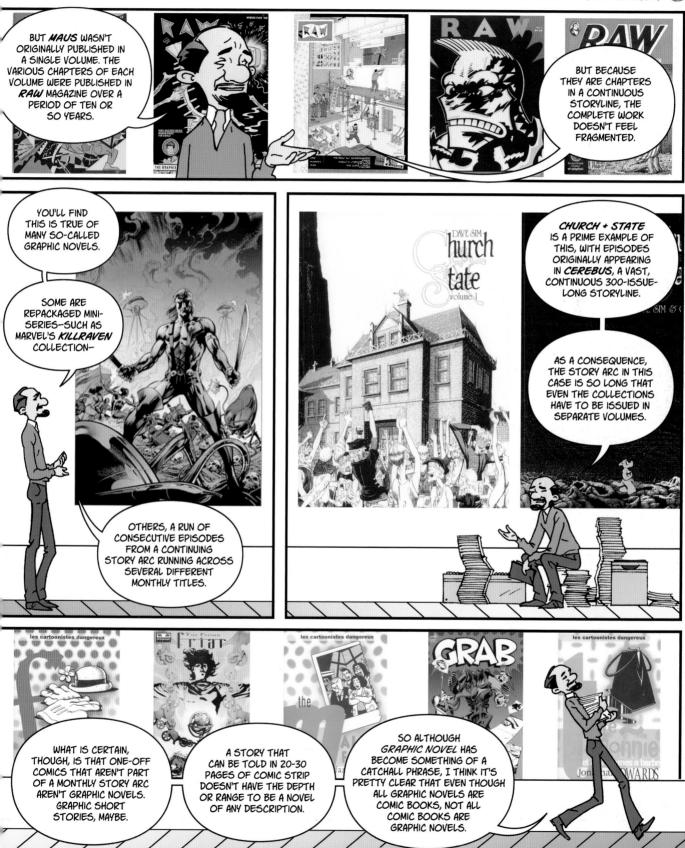

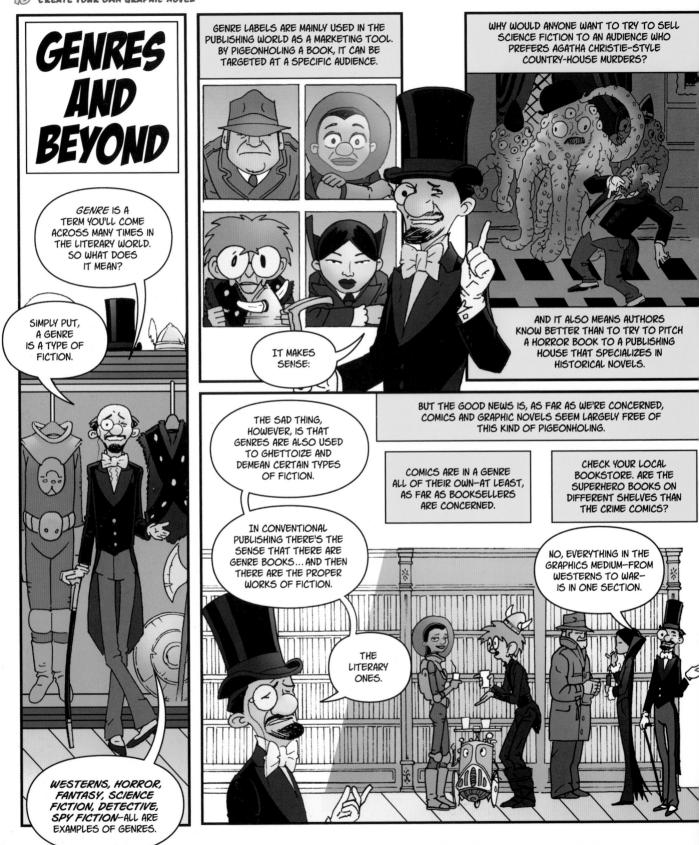

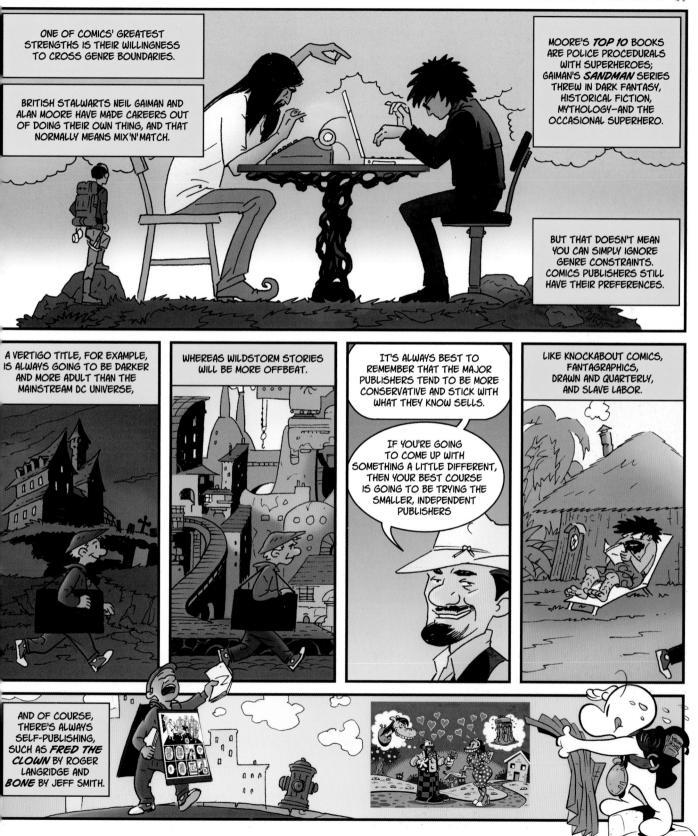

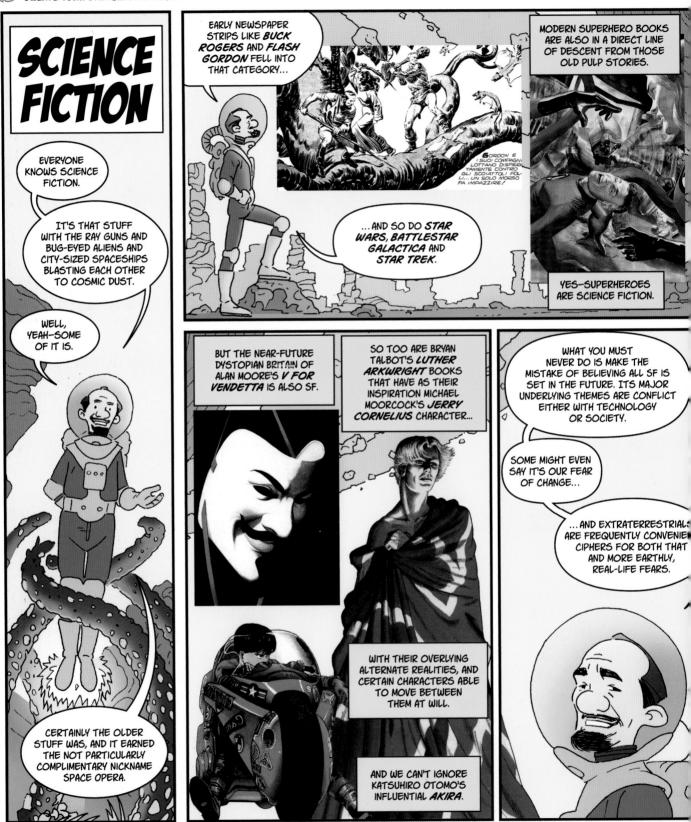

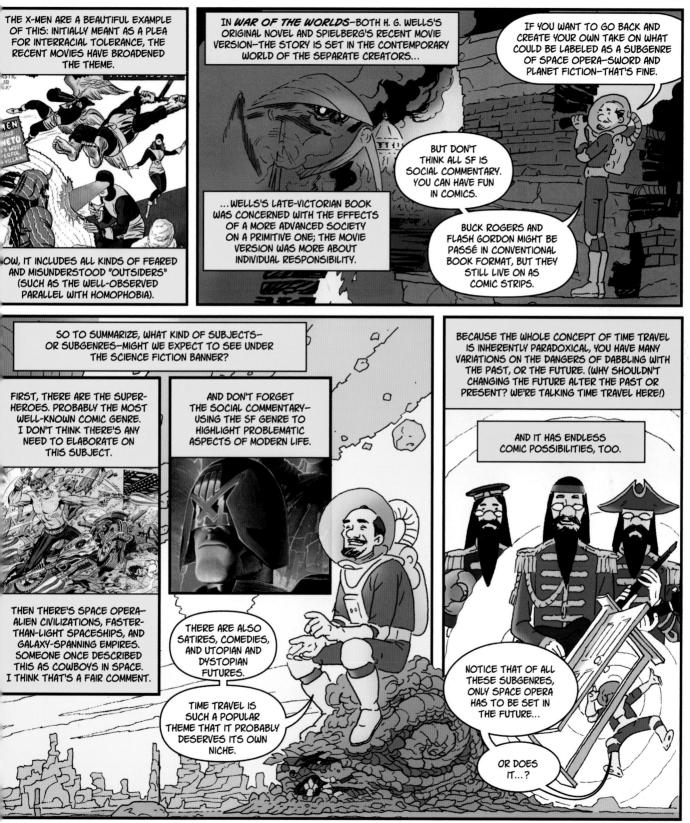

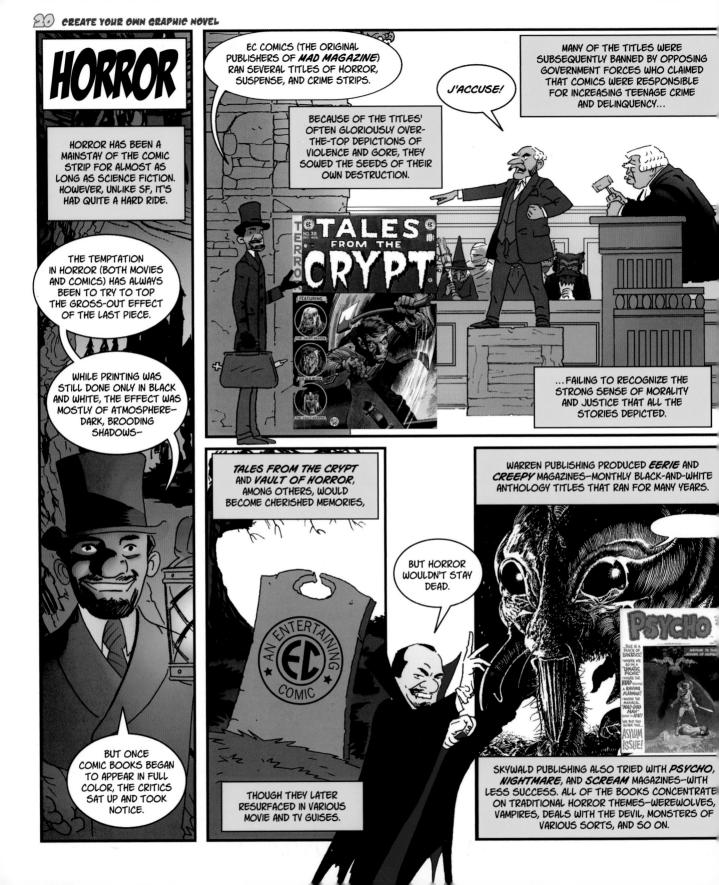

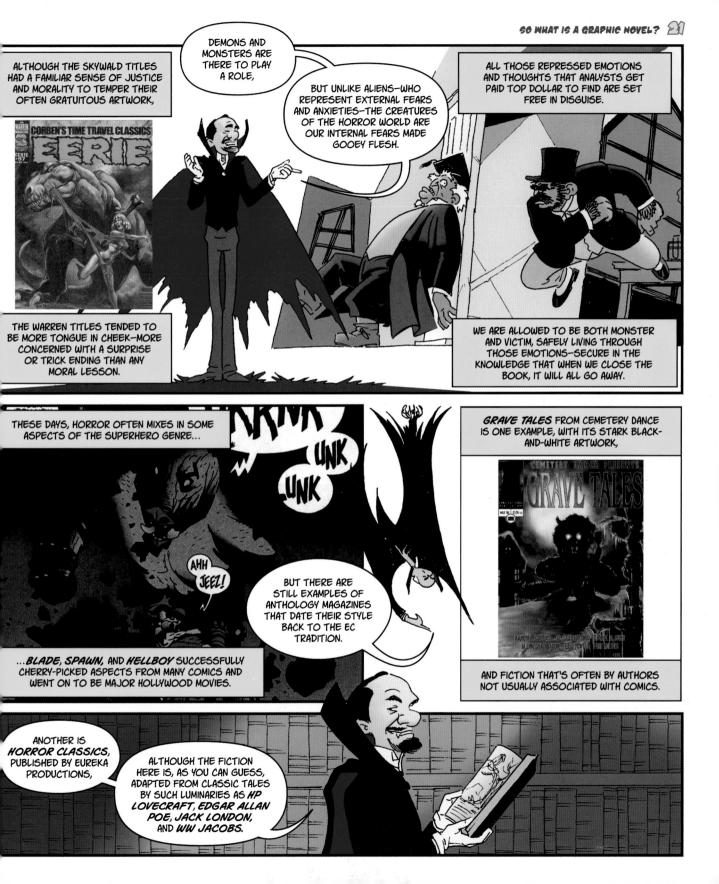

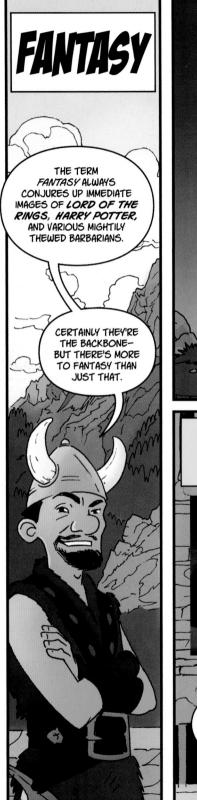

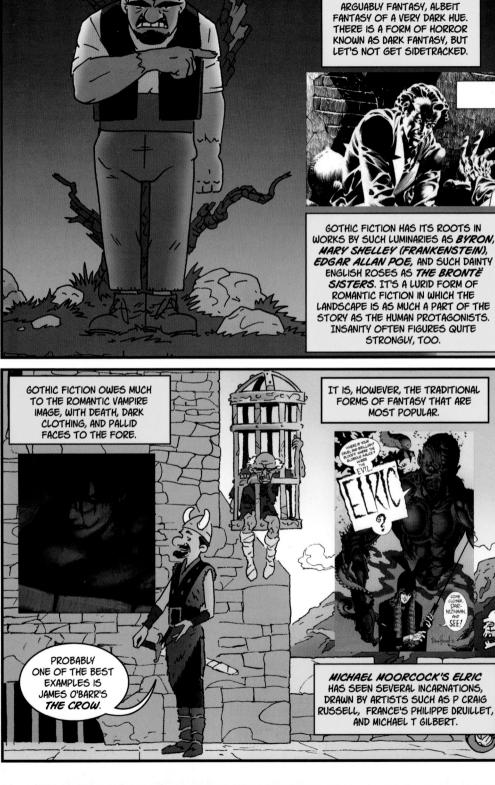

NEIL GAIMAN'S SANDMAN SERIES-ALONG WITH ALL ITS

VARIOUS SPIN-OFFS-IS

SO WHAT IS A GRAPHIC NOVEL?

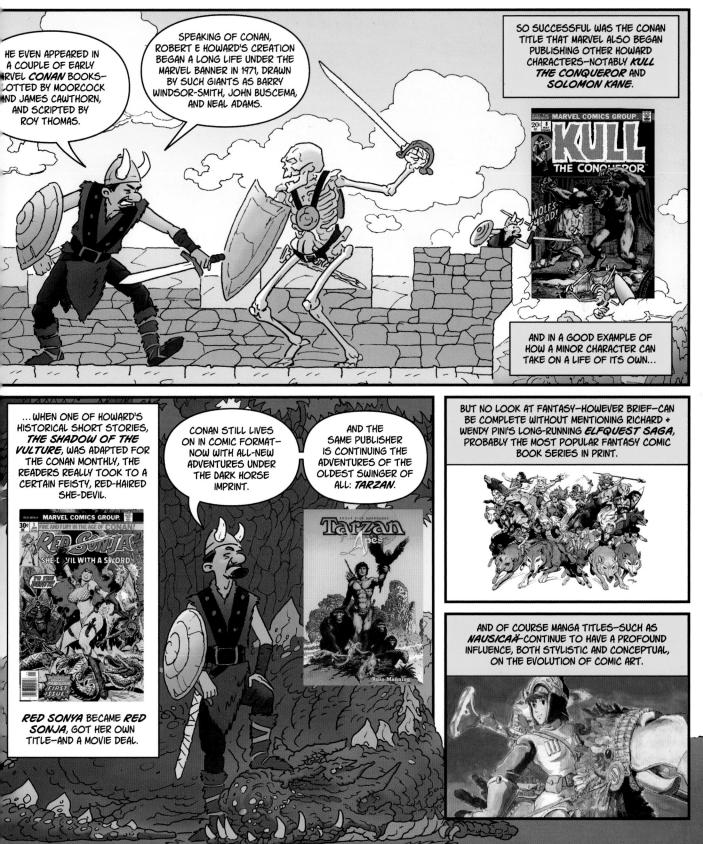

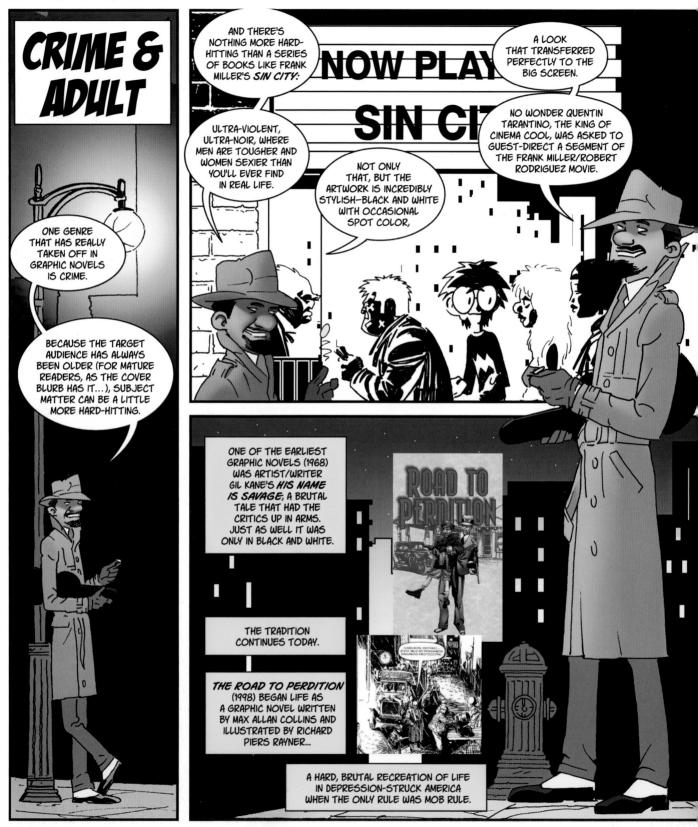

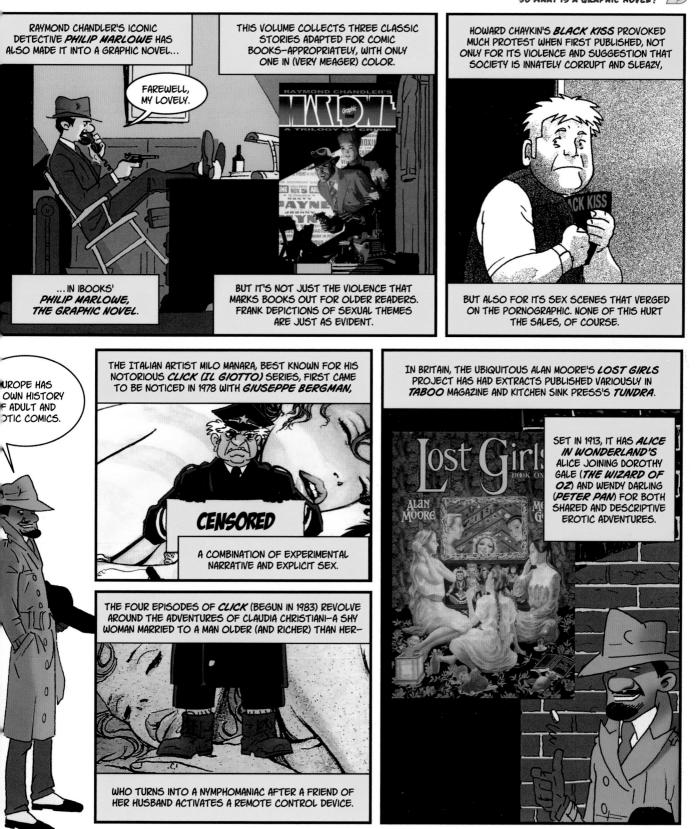

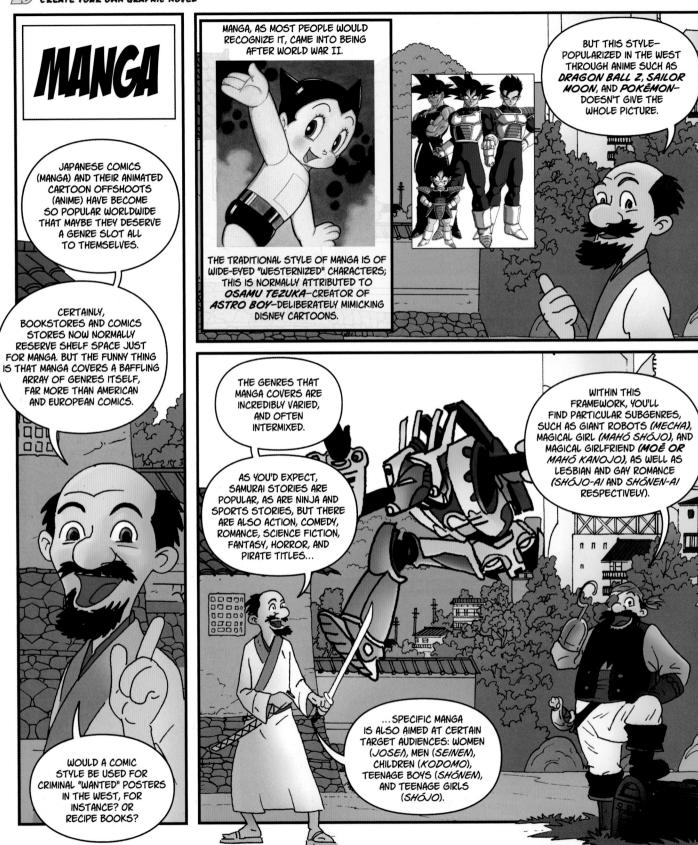

THE MANGA BANANA FISH

ALTOGETHER, YOU GET A MIX OF GENRE, SUBGENRE, AND SUB-SUBGENRE THAT MAY AT FIRST SEEM OVERWHELMING, BUT AT LEAST YOU KNOW WHAT YOU'RE GETTING.

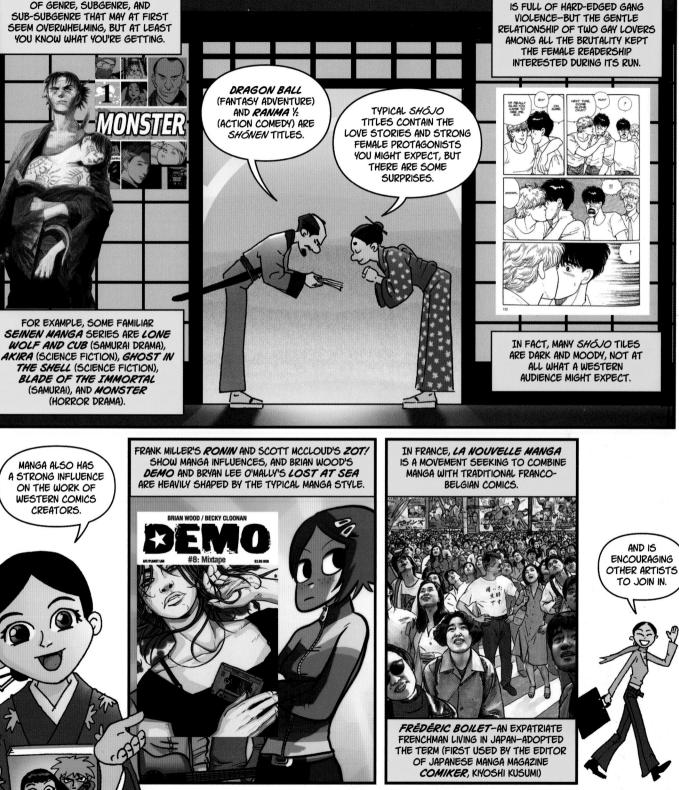

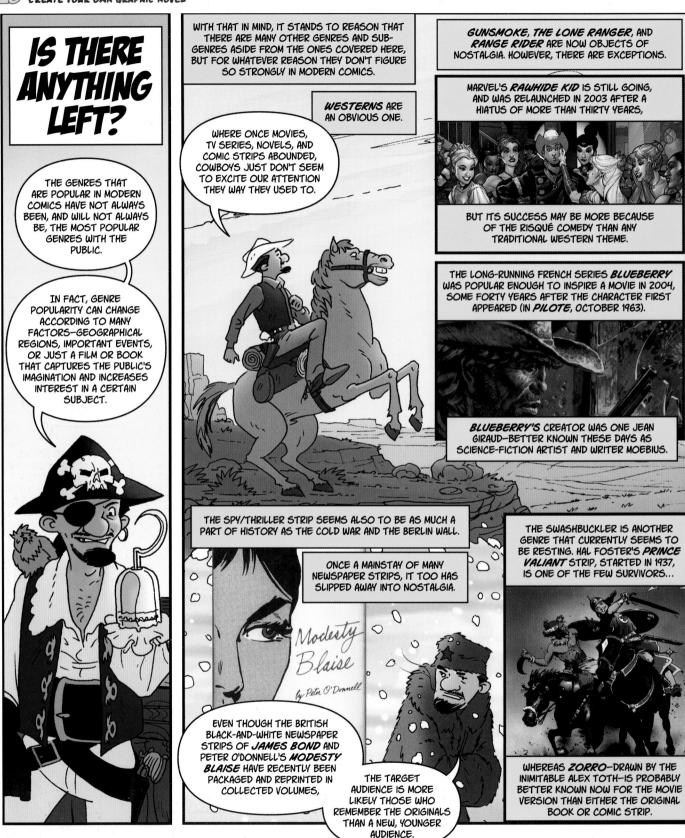

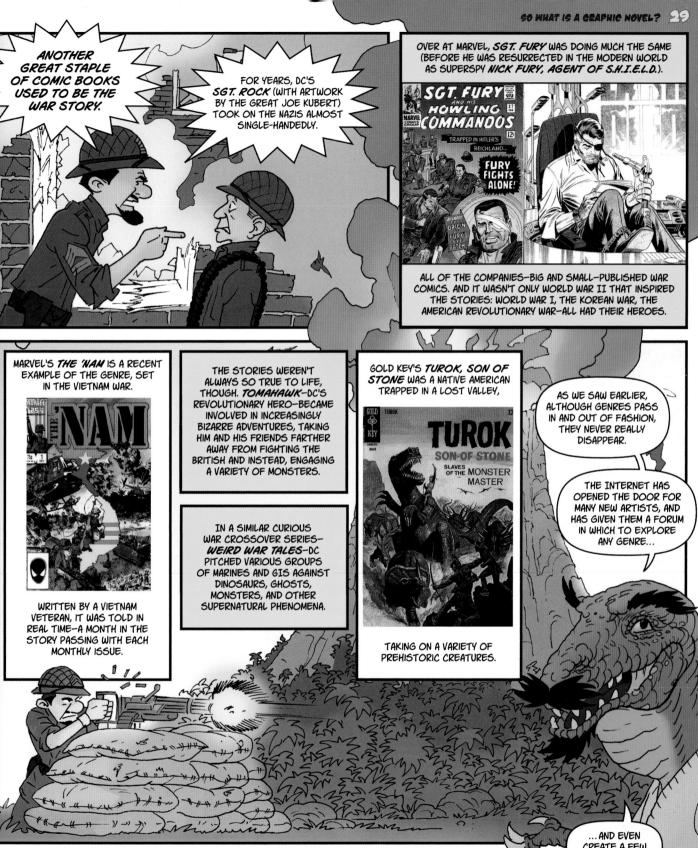

CREATE A FEW NEW ONES.

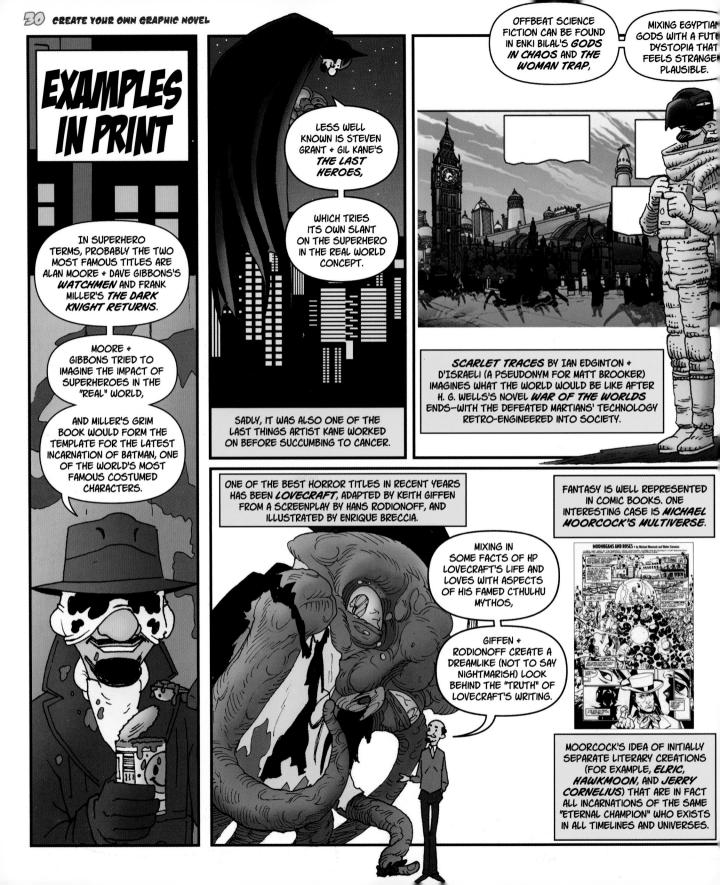

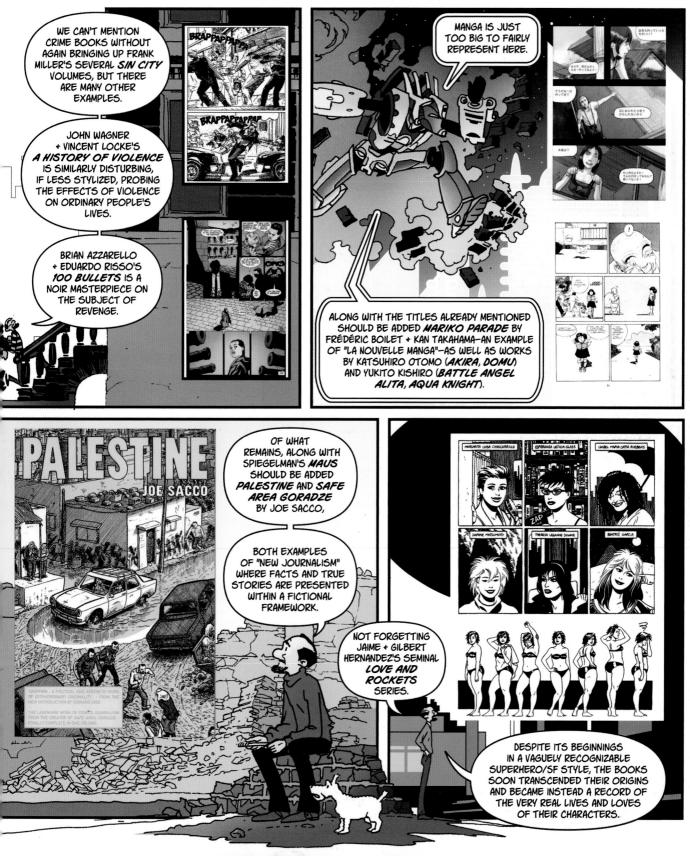

CHAPTER 2

TERMINOLOGY	34
FRAMES OR PANELS?	36
CONSTRUCTING A STORYLINE	38
BALLOONS + BOXES	40
CHARACTERIZATION	42

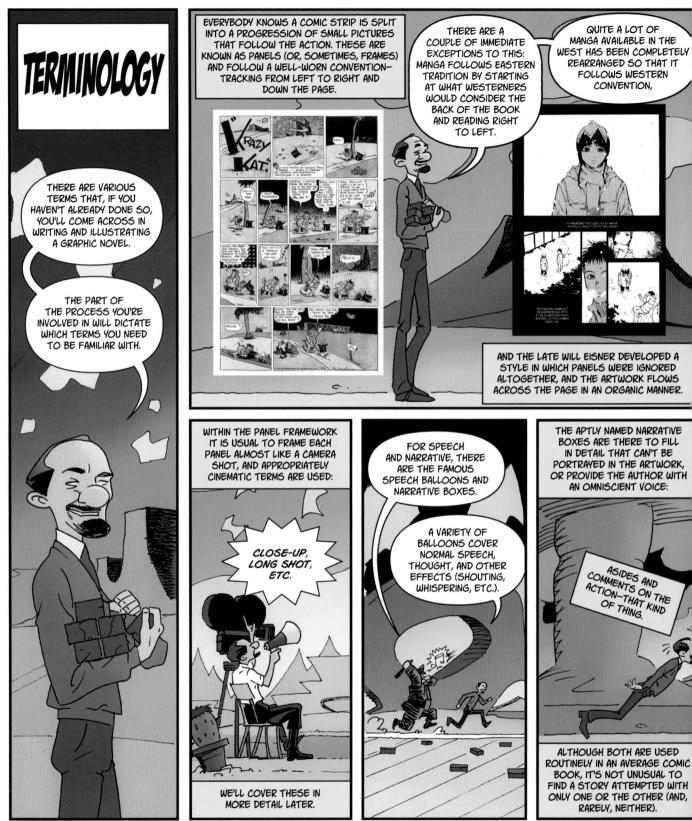

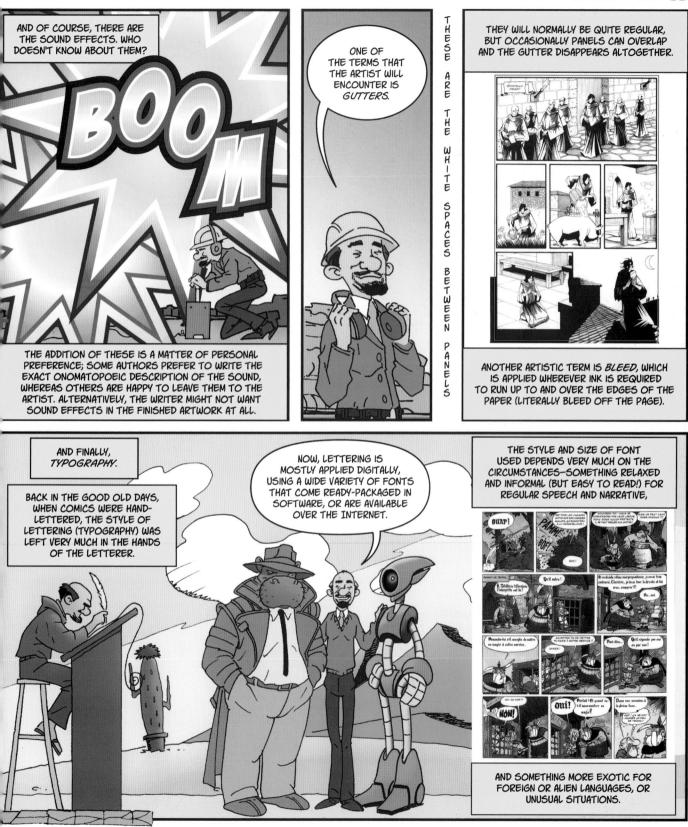

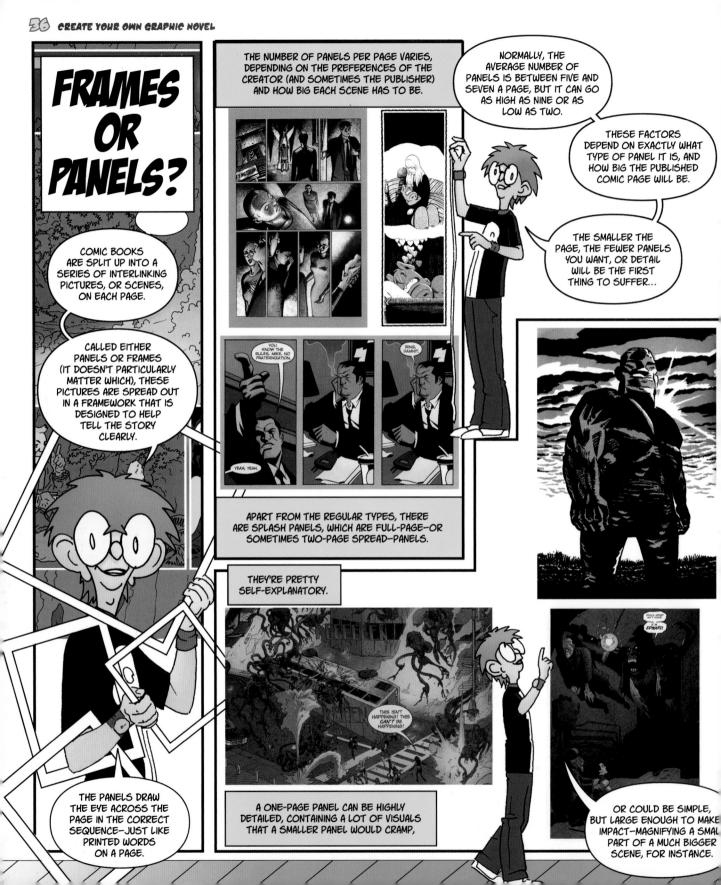

STRUCTURES AND ELEMENTS TY

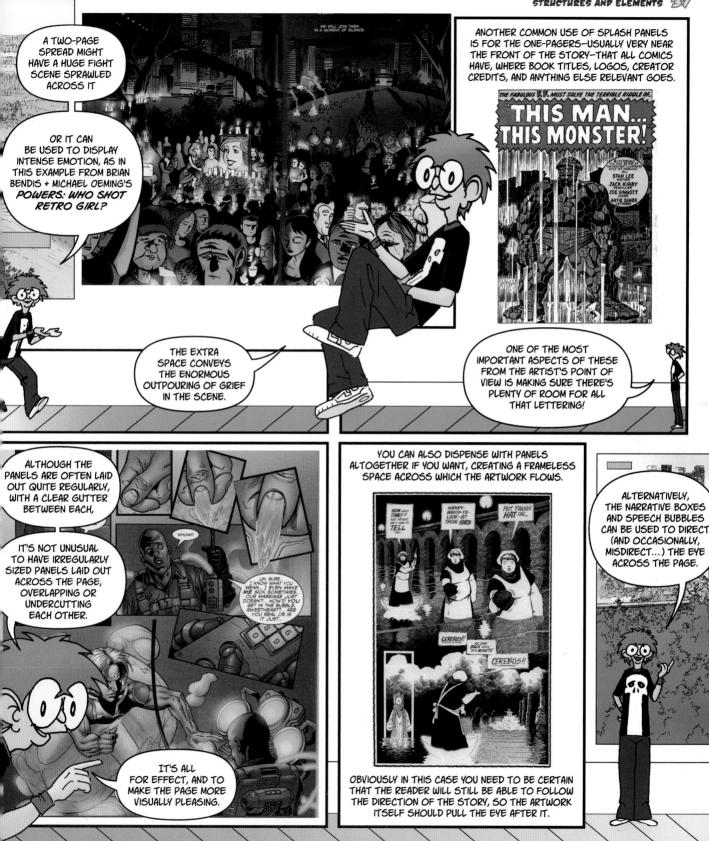

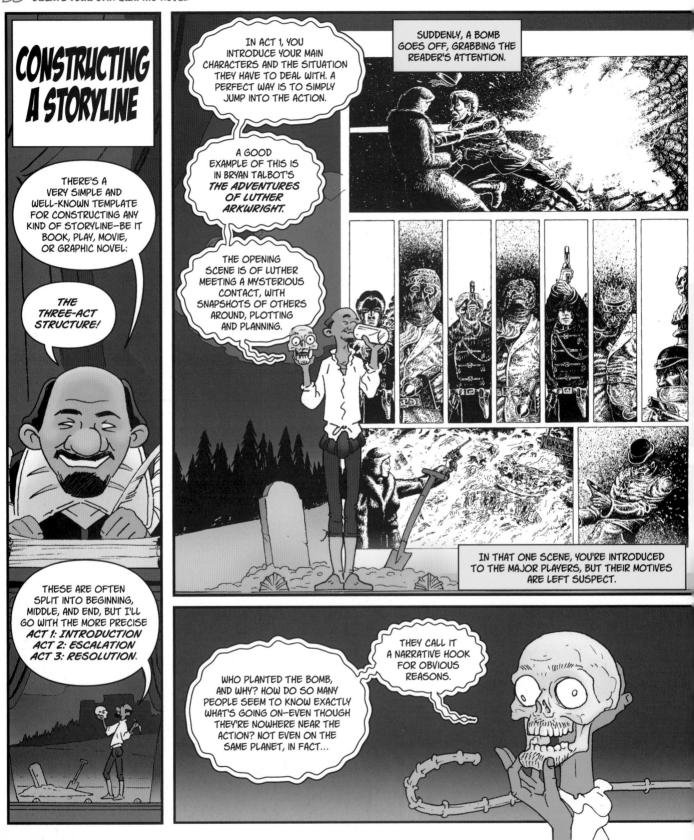

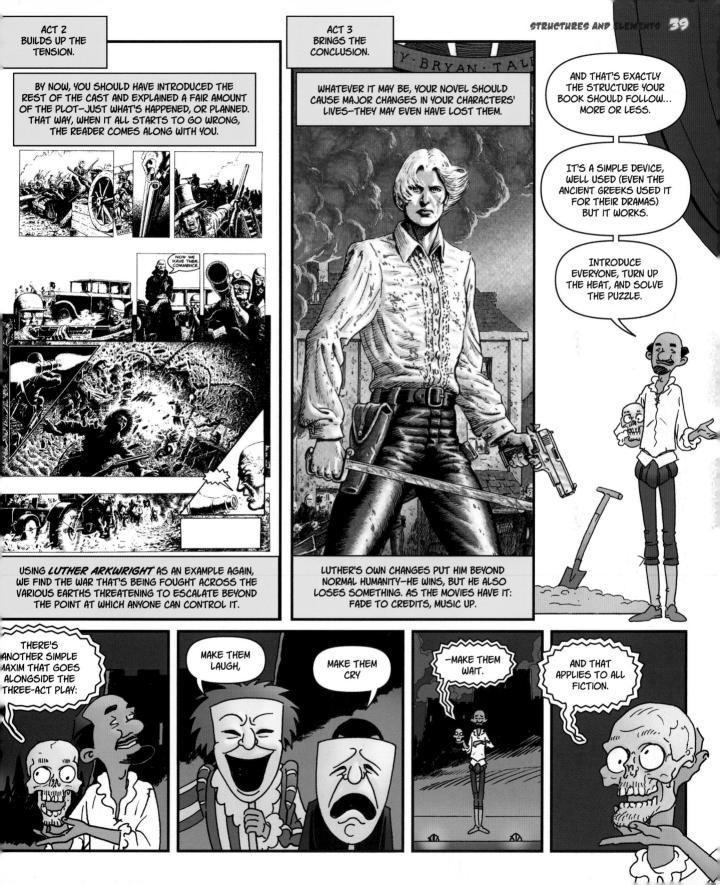

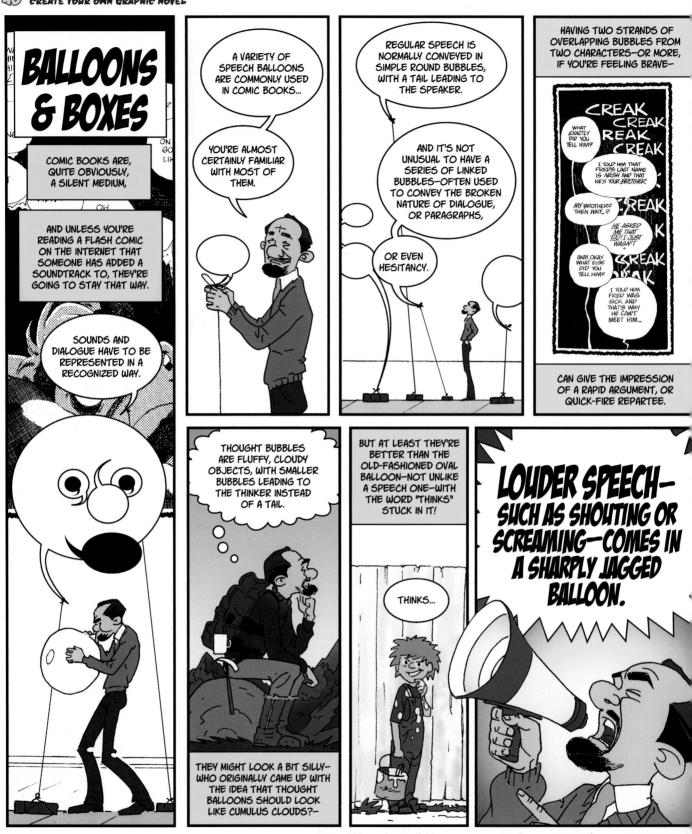

STRUCTURES AND ELEMENTS

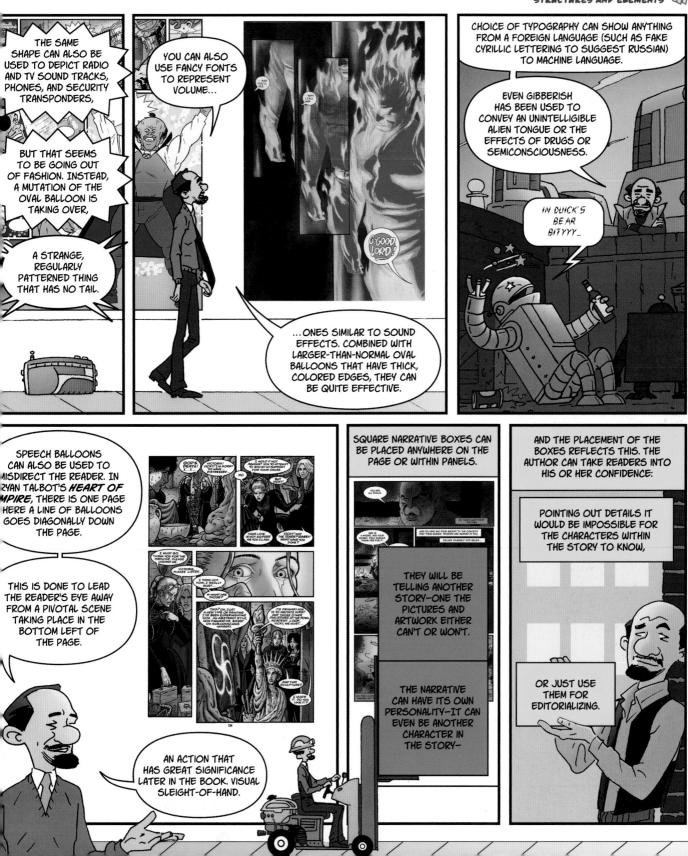

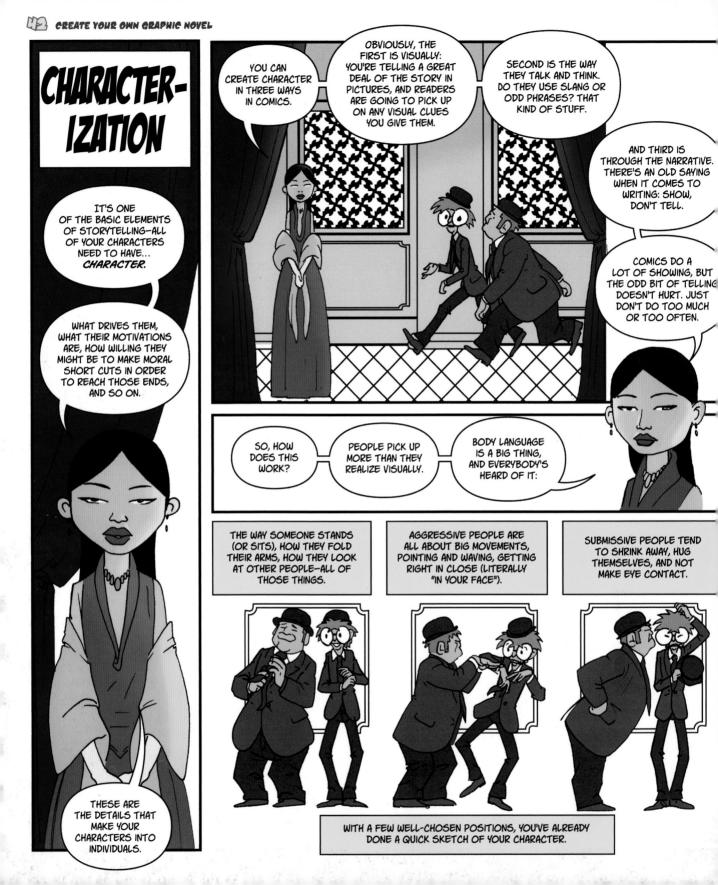

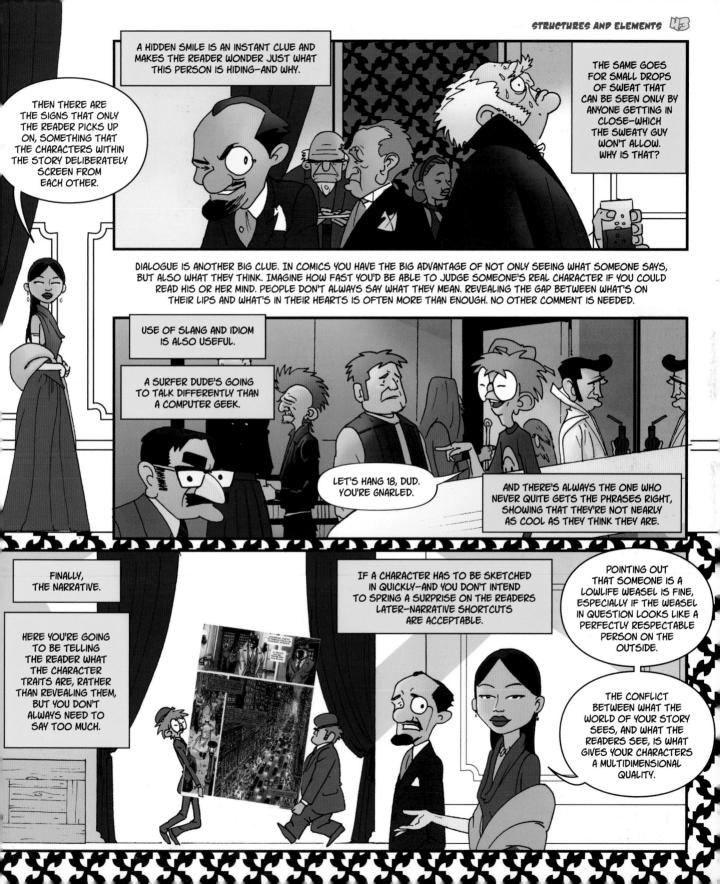

as creators

CHAPTER 3

QUICK REFERENCE		. 46
WORKING ONLINE		. 48
WORD-CRUNCHING		. 50
DRAWING WITH SOFTWARE		. 52
COLORING		. 54
SAVING		. 56
PUBLISHING: PRINT OR WEE	3?	. 58

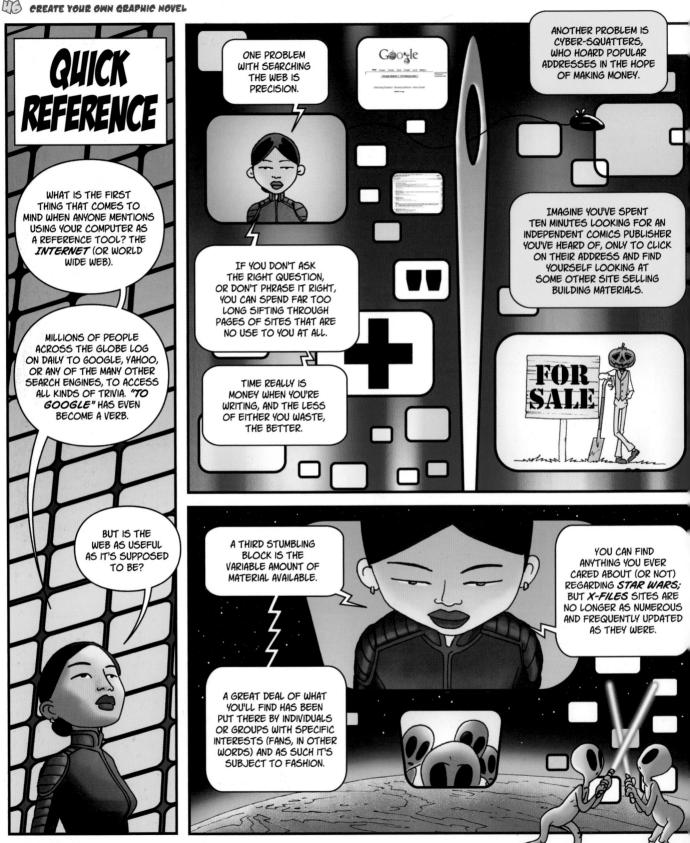

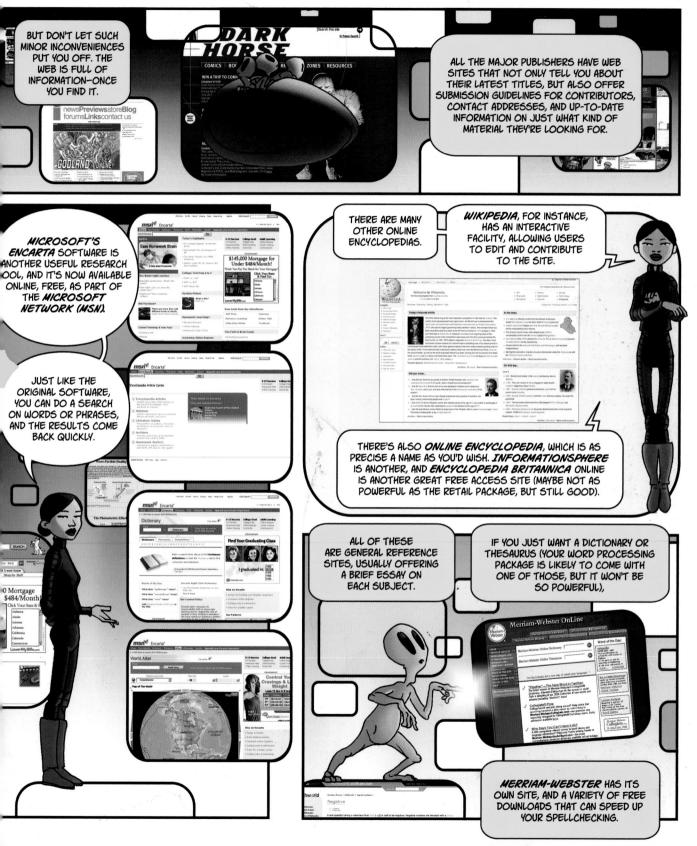

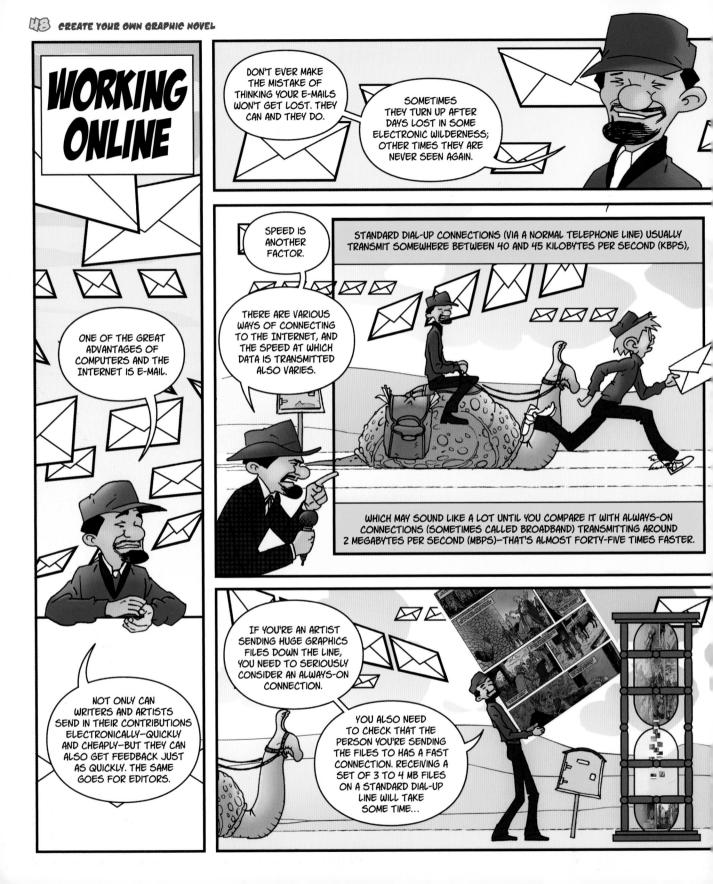

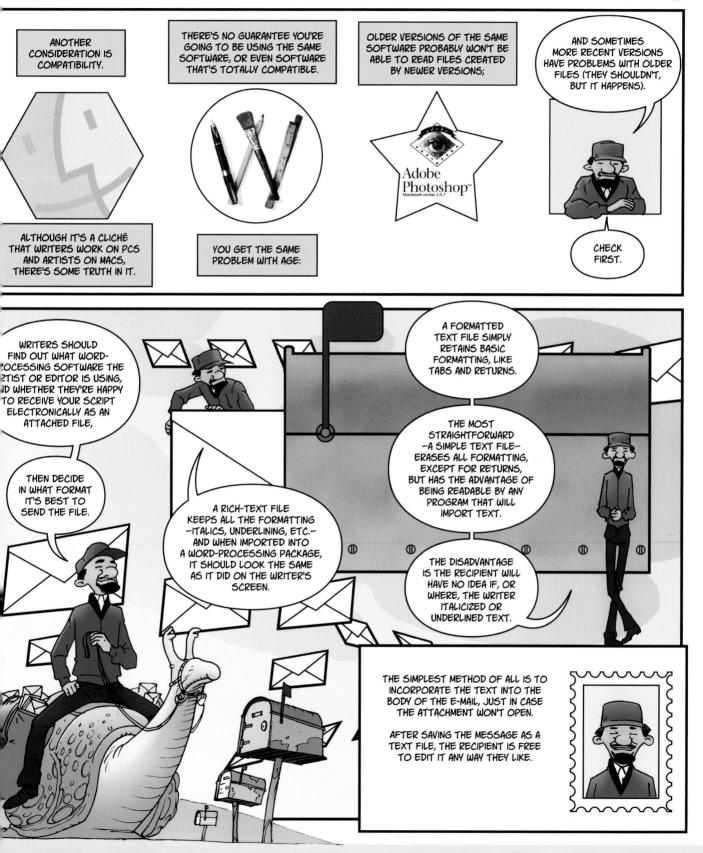

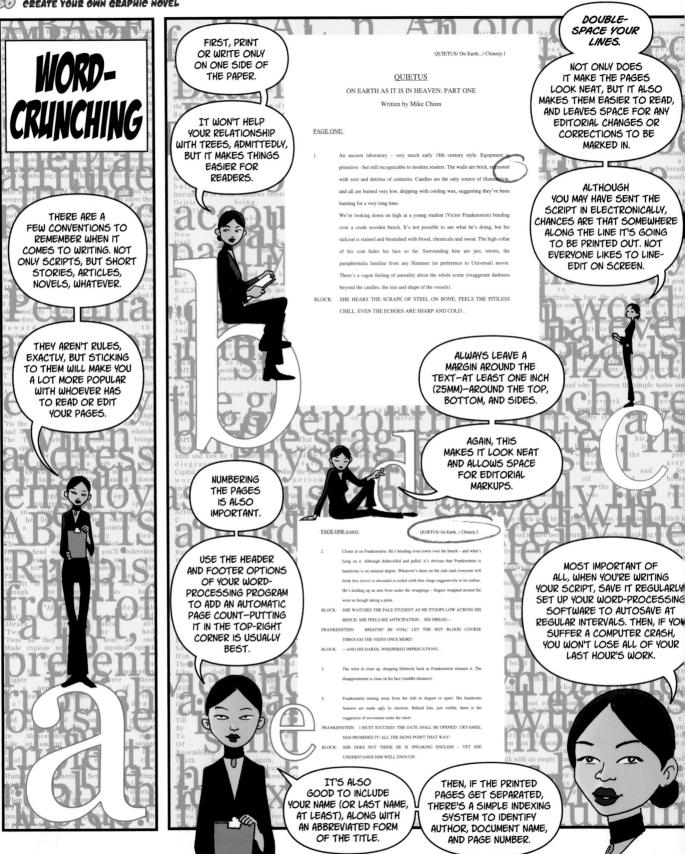

COMPUTERS AS CREATORS 🗐

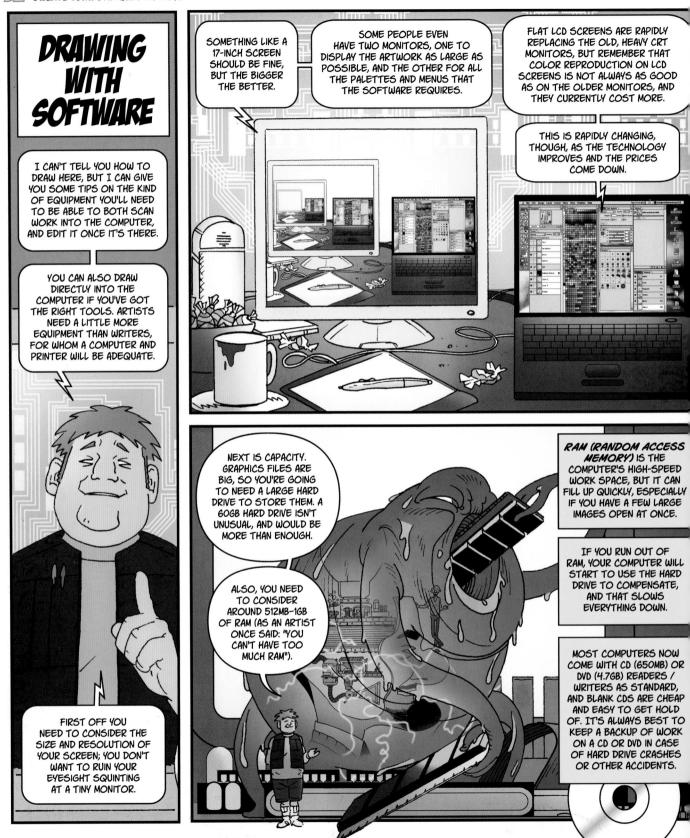

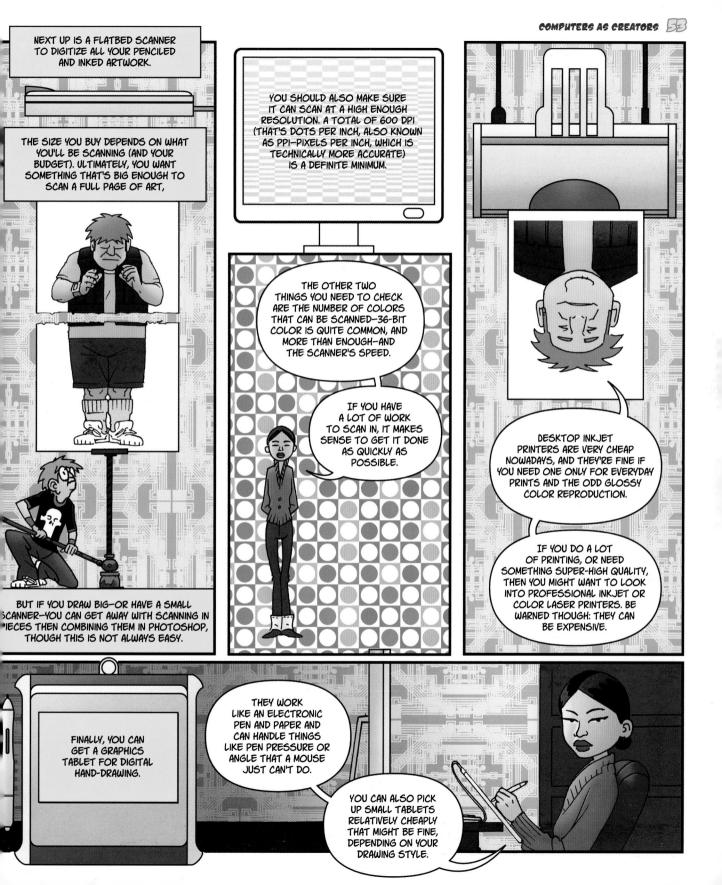

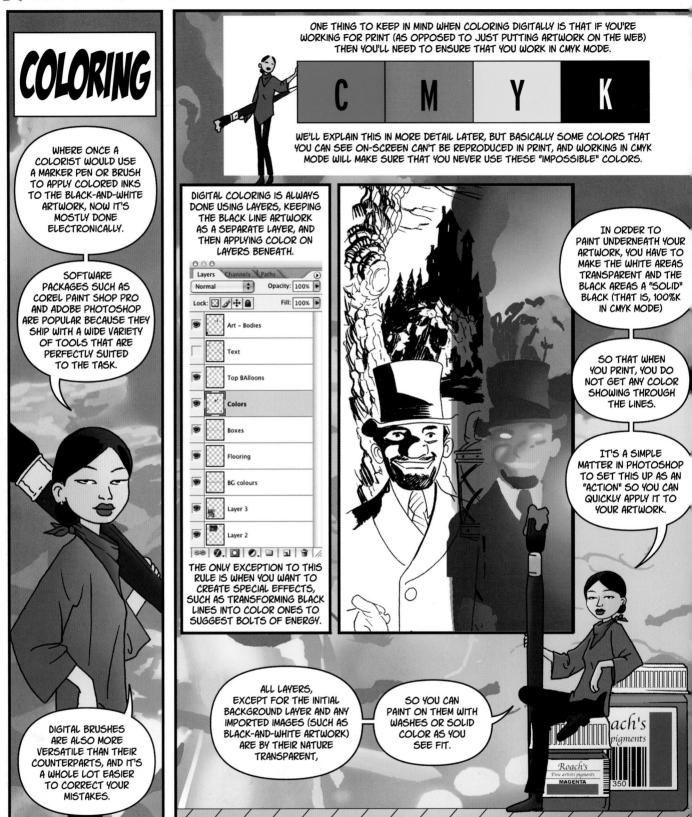

COMPUTERS AS CREATORS

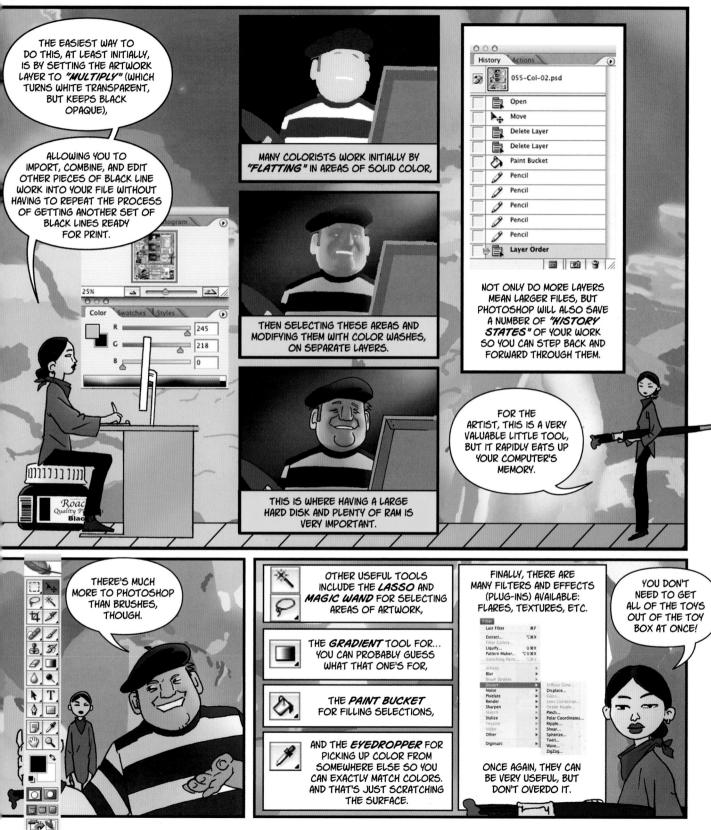

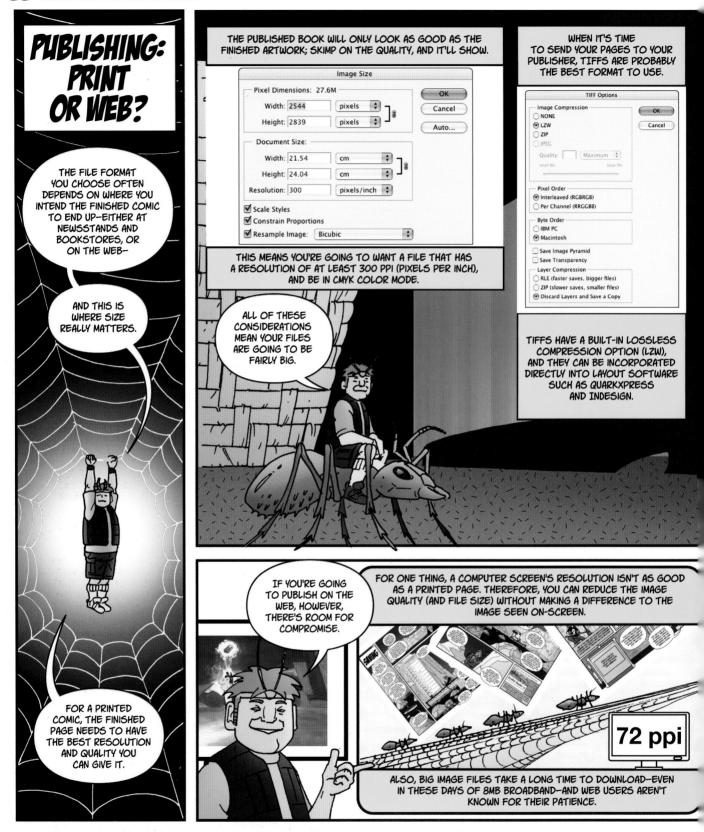

CHAPTER 4

INSPIRATION	62
OBSERVING PEOPLE	64
KEEPING NOTES AND RECORDS	66
DIGITAL CAMERAS	68

IDEAS FIRST

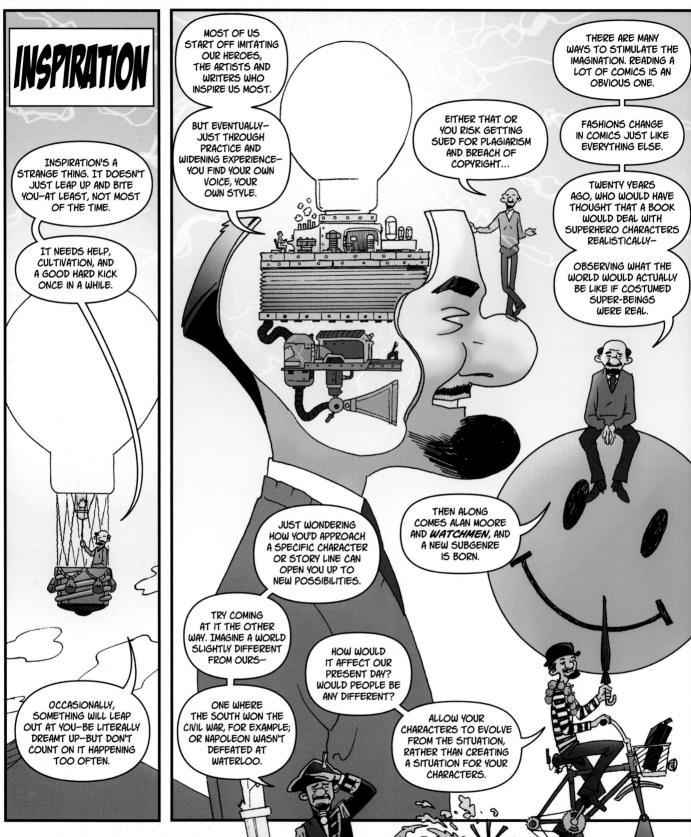

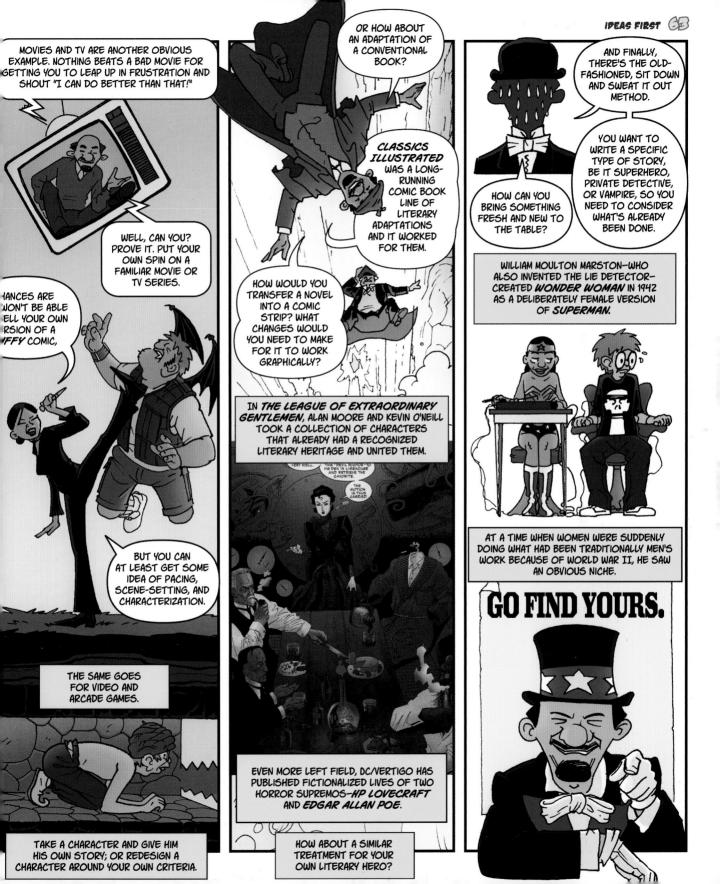

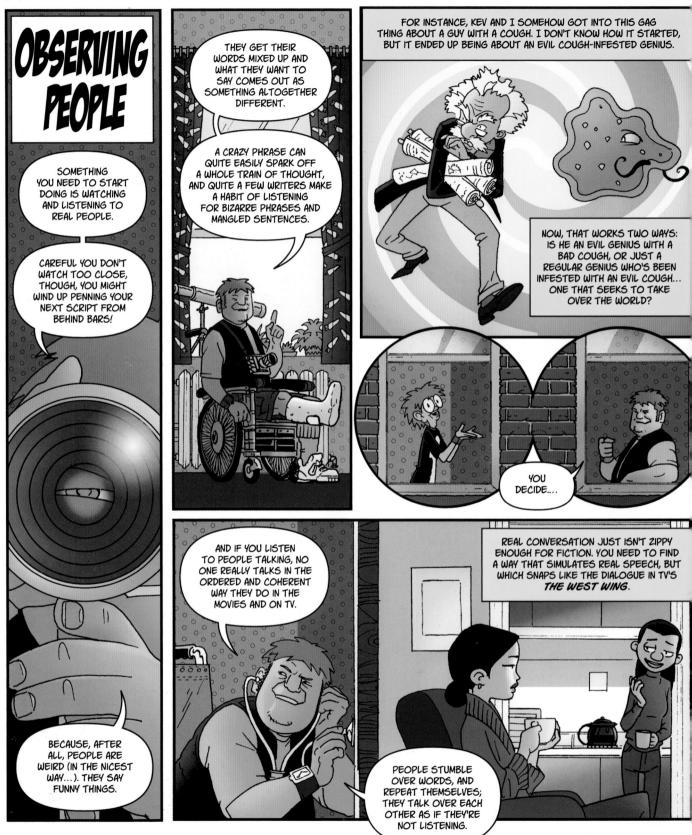

R

COMICS HAVE A UNIQUE POSITION HERE, WITH SPEECH BALLOONS GO LISTEN TO PEOPLE DOWN AT THE MALL, WATCH HOW FOLKS PHYSICALLY REACT YOU CAN OVERLAP AND WEAVE THEN COME HOME AND TRY TO FIGURE OUT TO EACH OTHER, GETTING IN CLOSE OR DIALOGUE IN A WAY THAT NO HOW YOU COULD ARRANGE IT ON THE PAGE. STANDING BACK; MAKING REAL EYE OTHER PRINTED AND DON'T FORGET BODY LANGUAGE. CONTACT, OR BEING SHIFTY MEDIUM CAN. R-Clark DO THEY MAKE WILD SHAPES WITH THEIR ARMS WHILE THEY TALK, OR DO THEY KEEP THEIR HANDS FIRMLY IN THEIR POCKETS? AND IT'S IT SEEMED TO BE NOT JUST PEOPLE CONSIDERING EVERYTHING; THAT ARE ODD. I ONCE ALMOST AS THOUGH IT SAW A SPARROW WAS WATCHING FOR WHATEVER, IT BEHAVING IN THE SOMETHING-OR ENDED UP IN THE NEXT WEIRDEST WAY. SOMEONE-IN PARTICULAR. ISSUE OF LOS BROS MORE LIKE A PERSON AS MELVIN THE THAN AN ANIMAL. WERESPARROW. INSTEAD OF TWITCHING AROUND LIKE BIRDS DO, IT WAS PERCHED ON A WALL, OUTSIDE A COFFEE SHOP, WATCHING PEOPLE COMING AND GOING WITH SLOW, CAREFUL ACTIONS. I DON'T KNOW WHY IT WAS BEHAVING LIKE THAT, MAYBE IT WAS SICK. OR MAYBE IT WASN'T REALLY A BIRD? MAYBE IT WAS A THOUGHT PROJECTION CONCEALING ITS REAL ALIEN FORM?

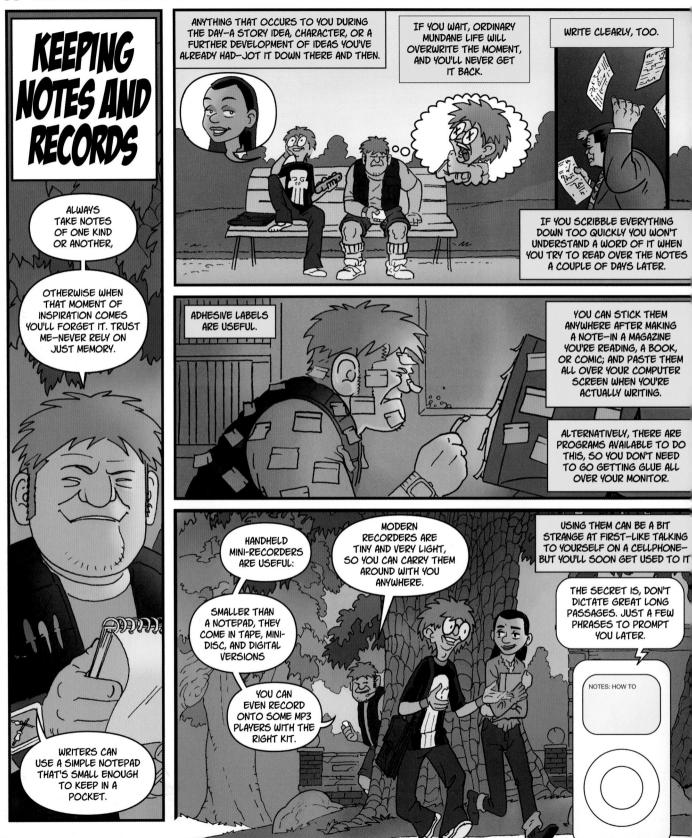

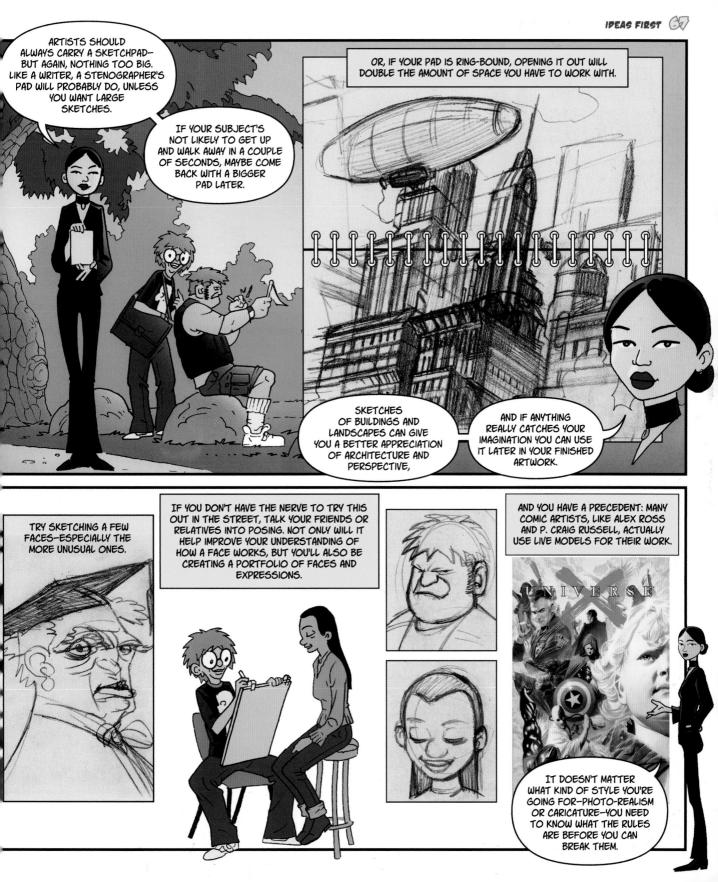

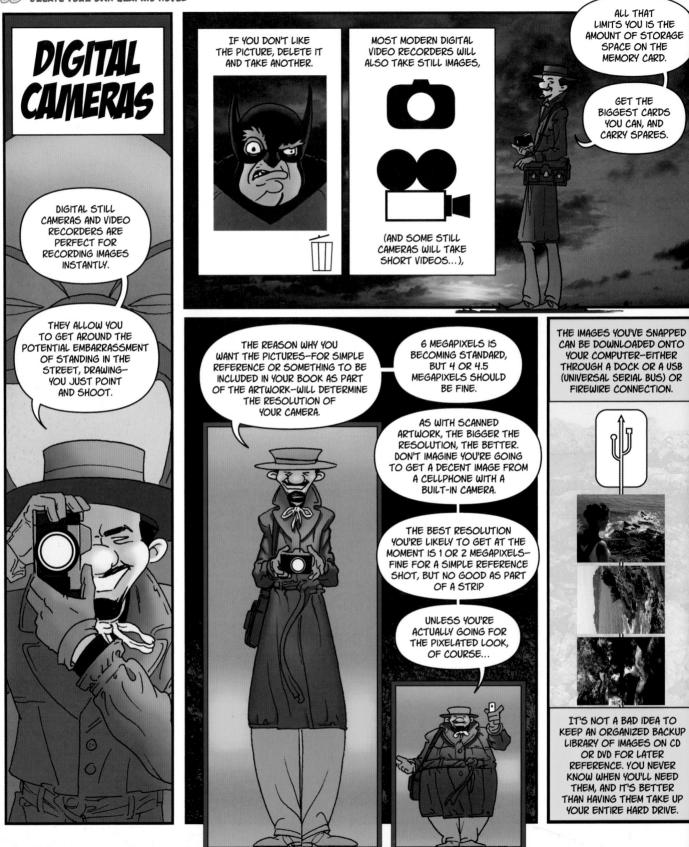

ONCE YOU'VE IMPORTED YOUR DIGITAL SNAPS INTO PHOTOSHOP, YOU CAN TWEAK THEM IN MANY WAYS-FROM SIMPLE COLOR OR CONTRAST ADJUSTMENTS TO INCREDIBLY COMPLEX MULTILAYERED MONTAGES.

PHOTOSHOP ALSO WORKS WELL WITH ILLUSTRATOR-A POPULAR DIGITAL DRAWING PROGRAM-SO IT'S EASY TO COMBINE PHOTOGRAPHIC IMAGES WITH YOUR DRAWN OR SCANNED ARTWORK.

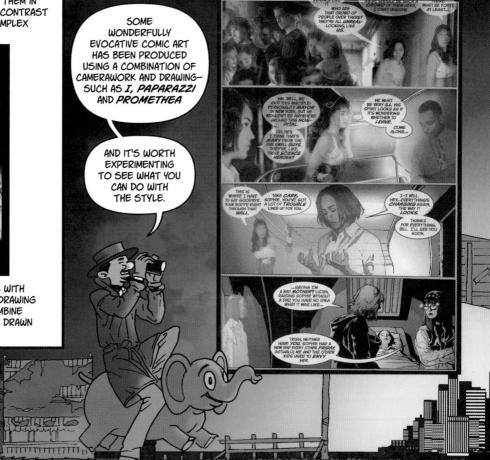

CHAPTER 5

WRITING STYLES 72
FULL SCRIPT VERSUS PLOT METHODS
ONLINE COLLABORATION
PACE
CHARACTER DEVELOPMENT
SETTING
USE OF MOVIE TECHNIQUES
RESEARCH
WRITING A BRIEF AND SYNOPSIS

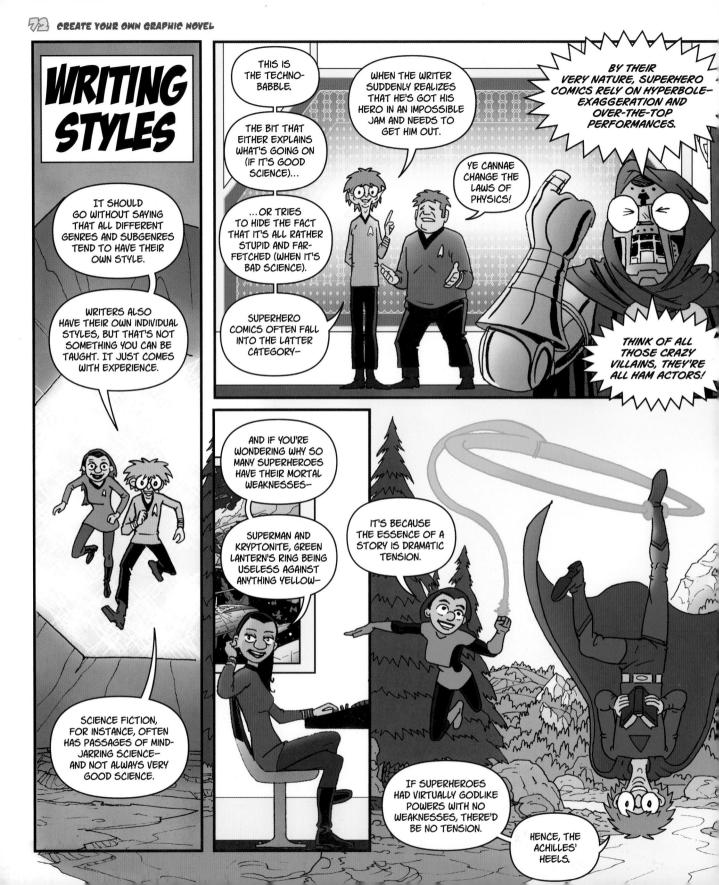

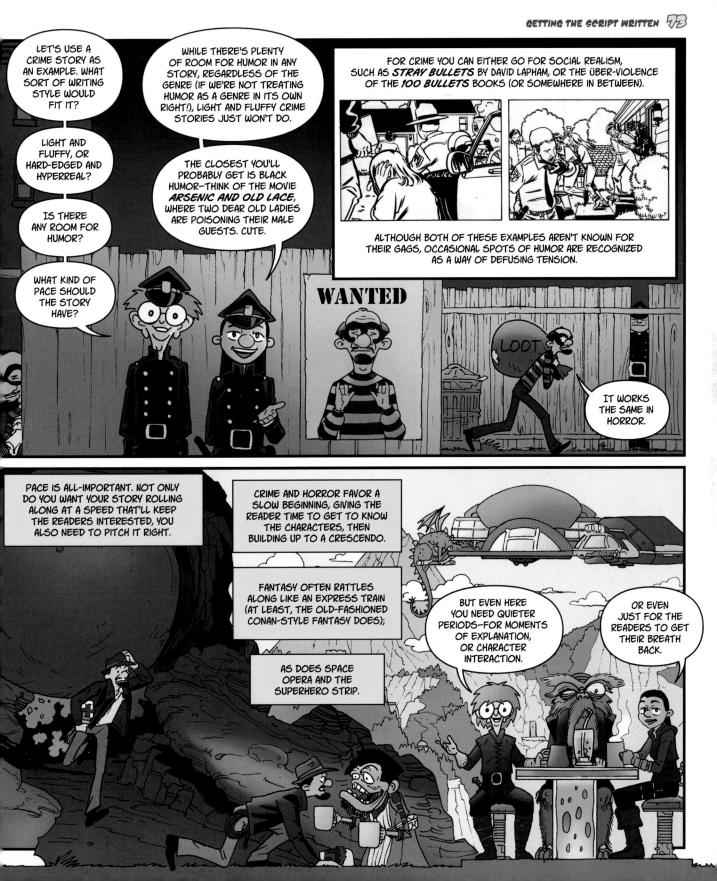

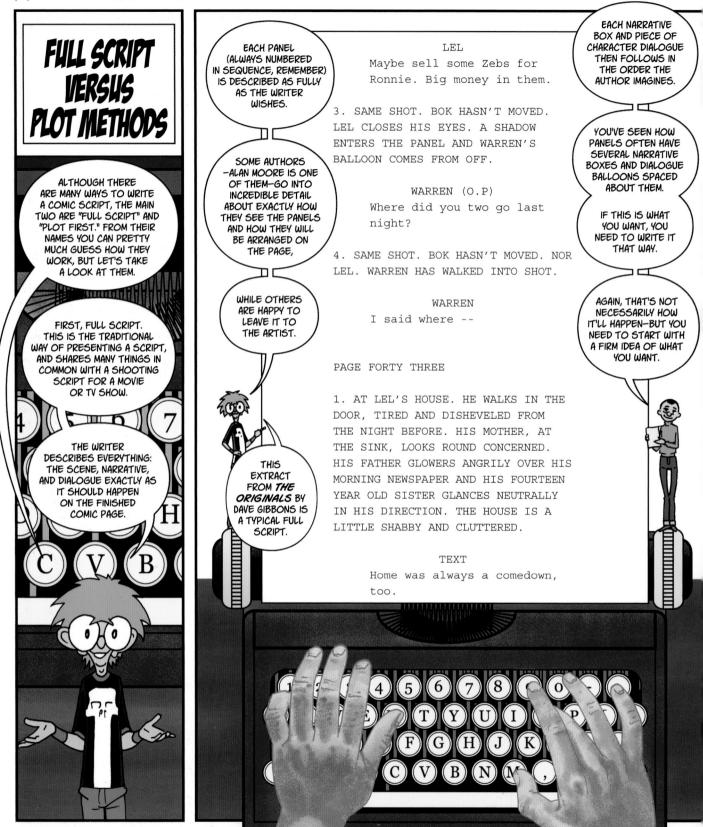

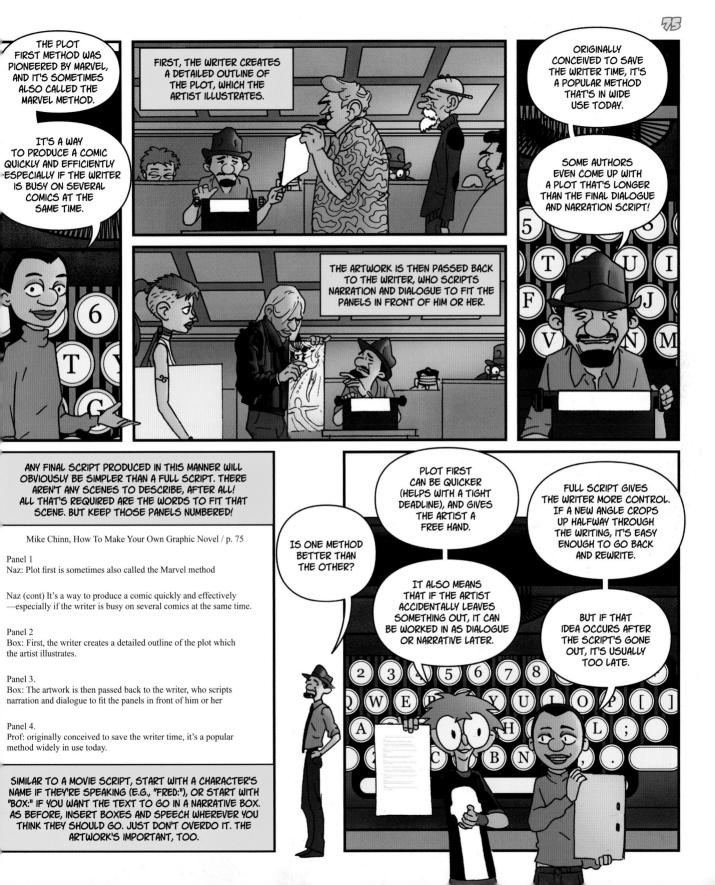

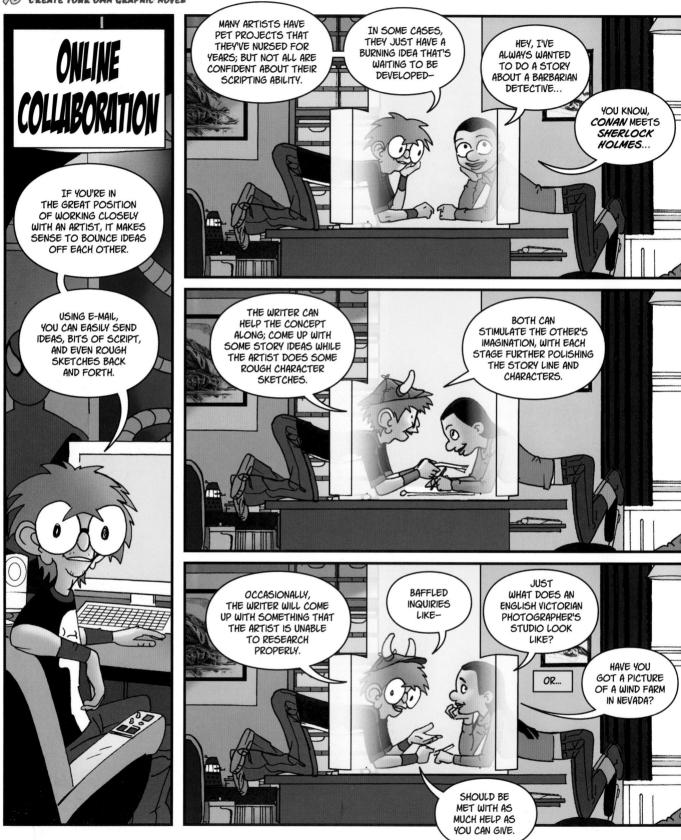

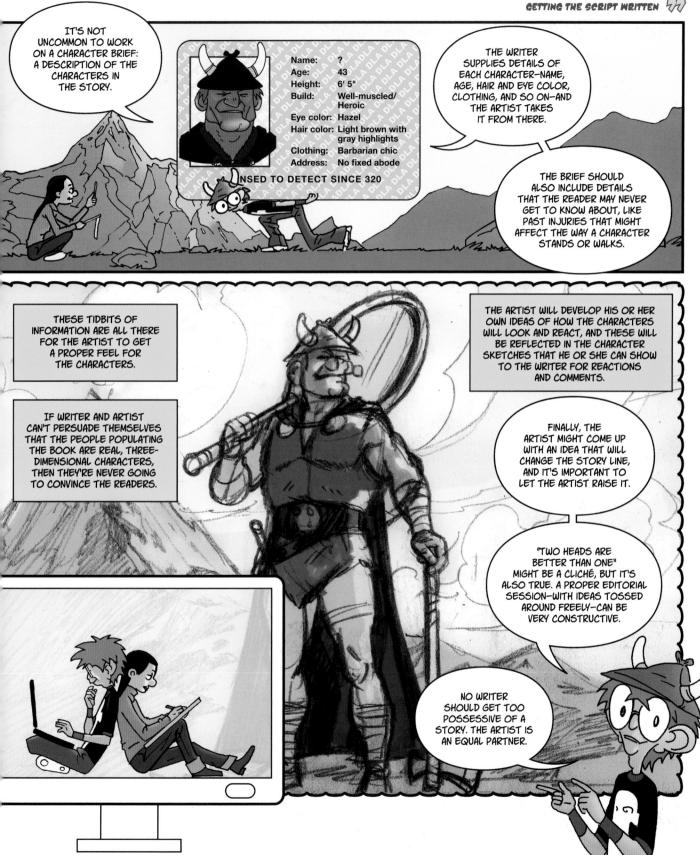

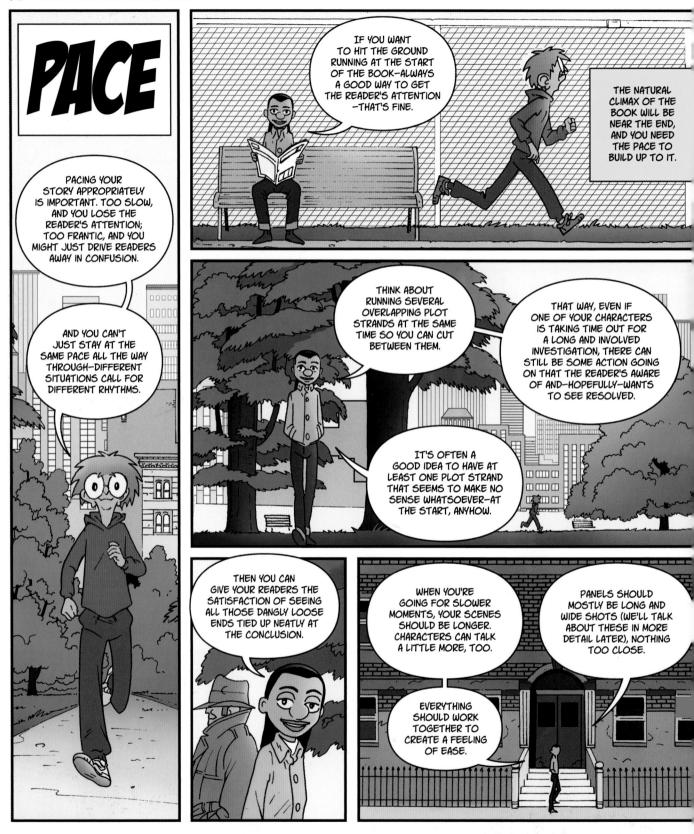

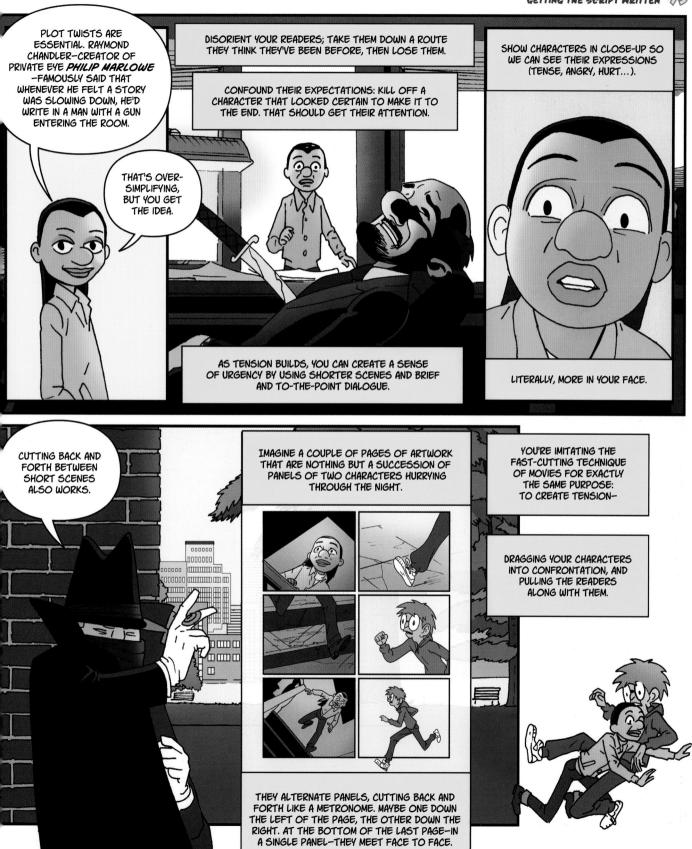

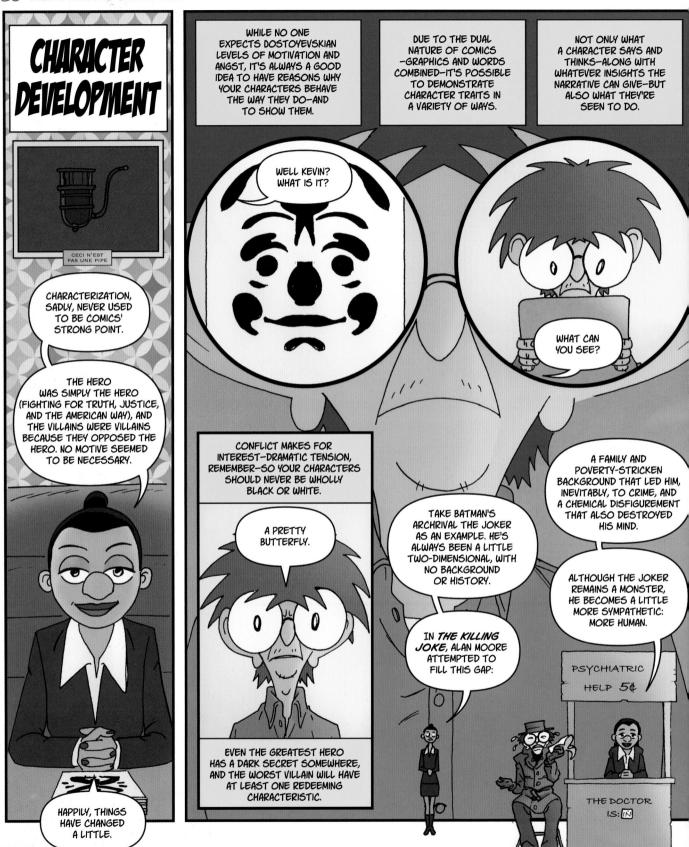

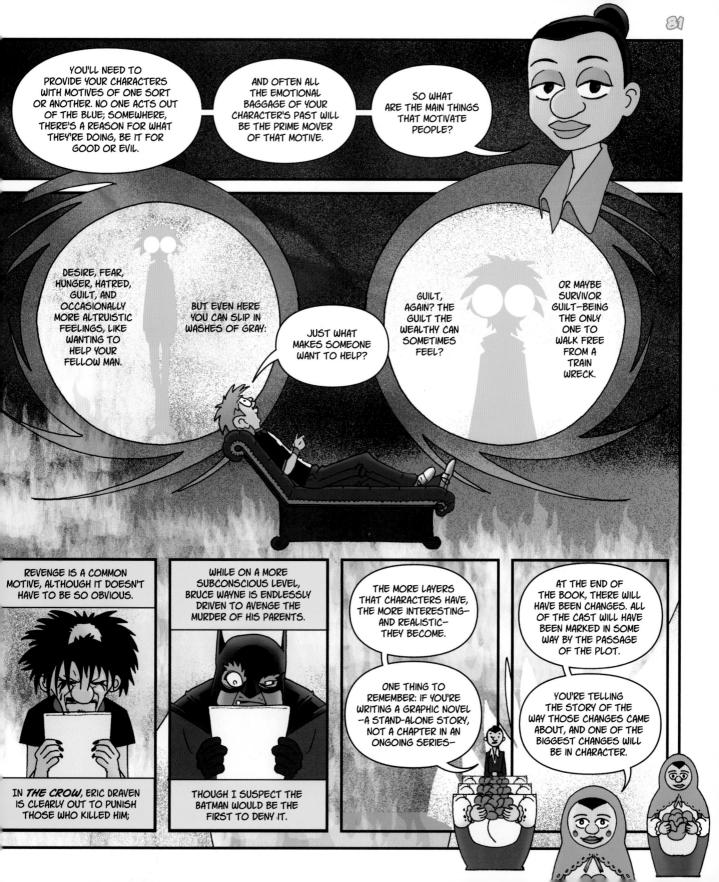

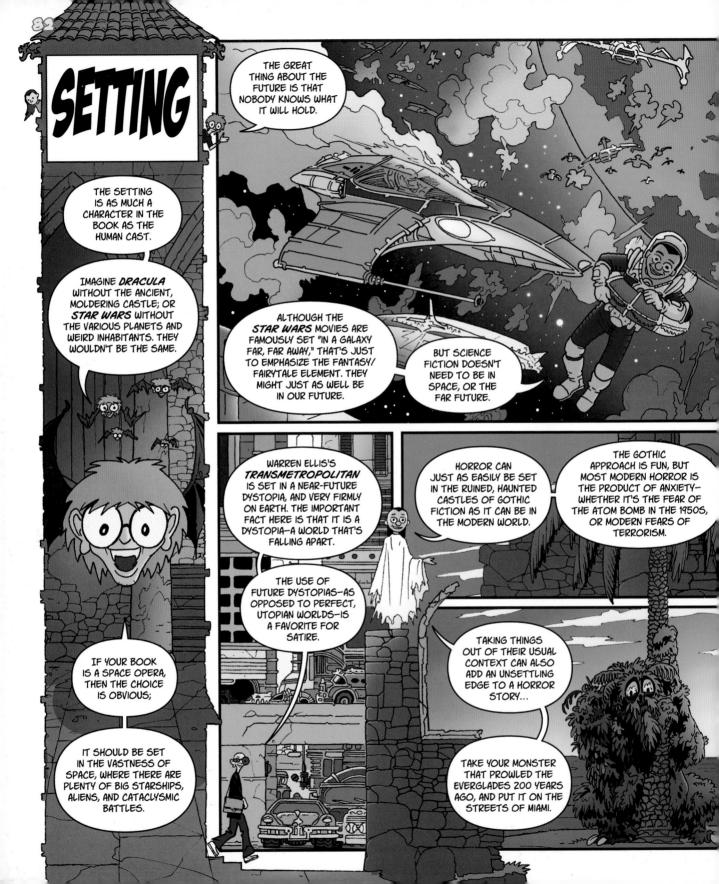

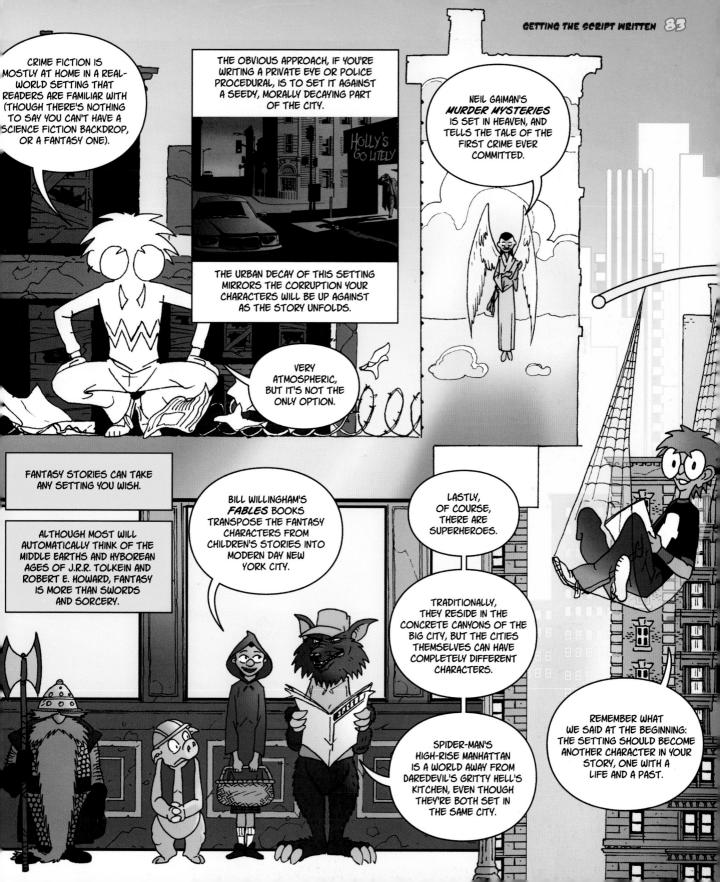

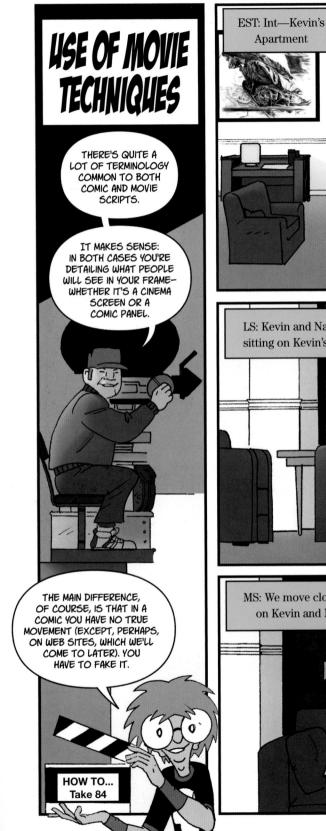

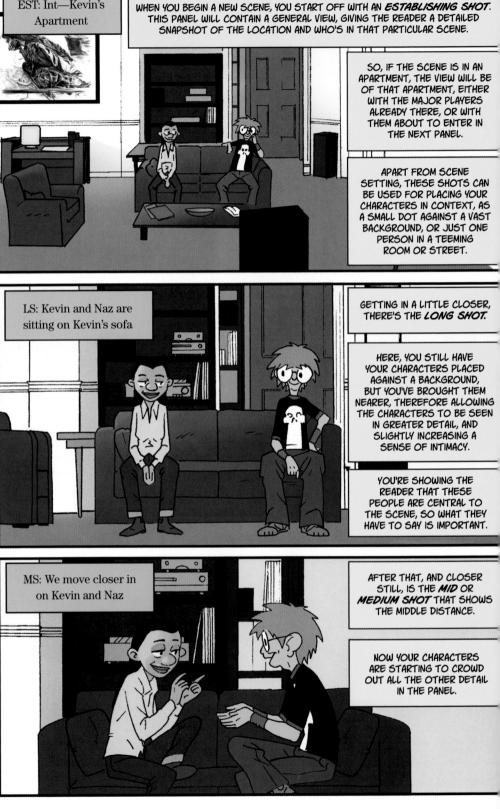

GETTING THE SCRIPT WRITTEN 85

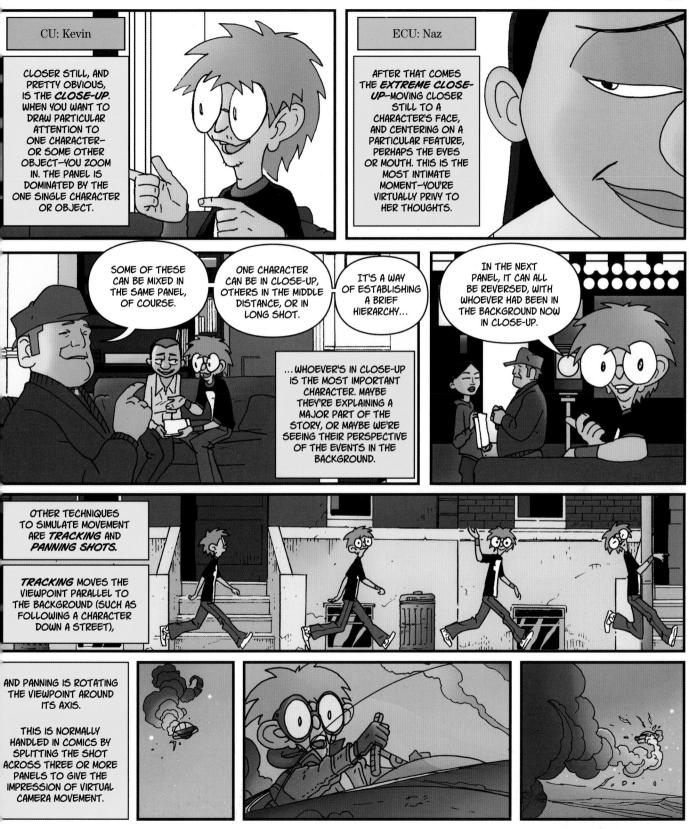

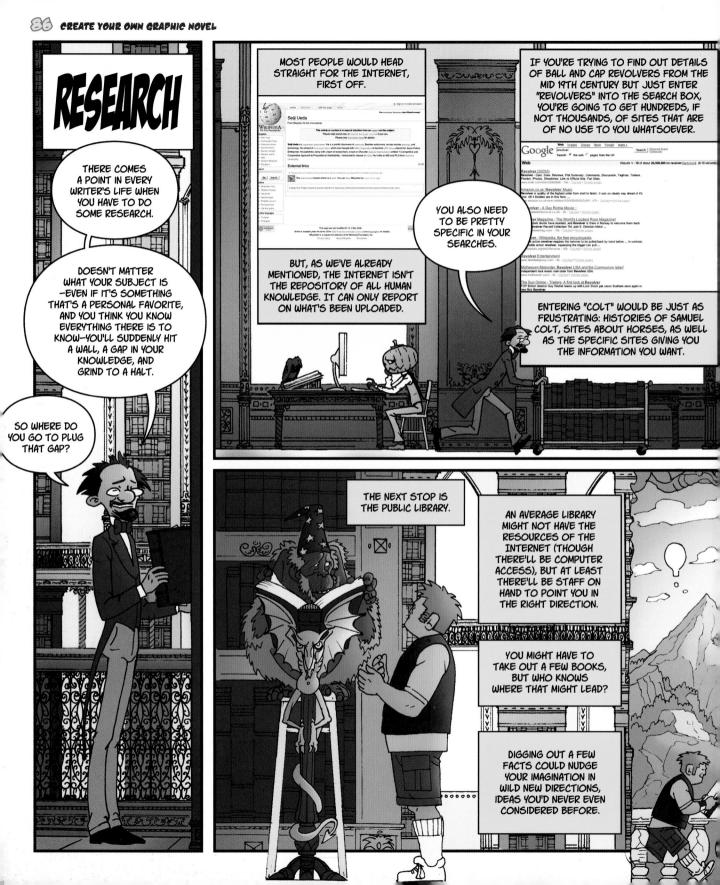

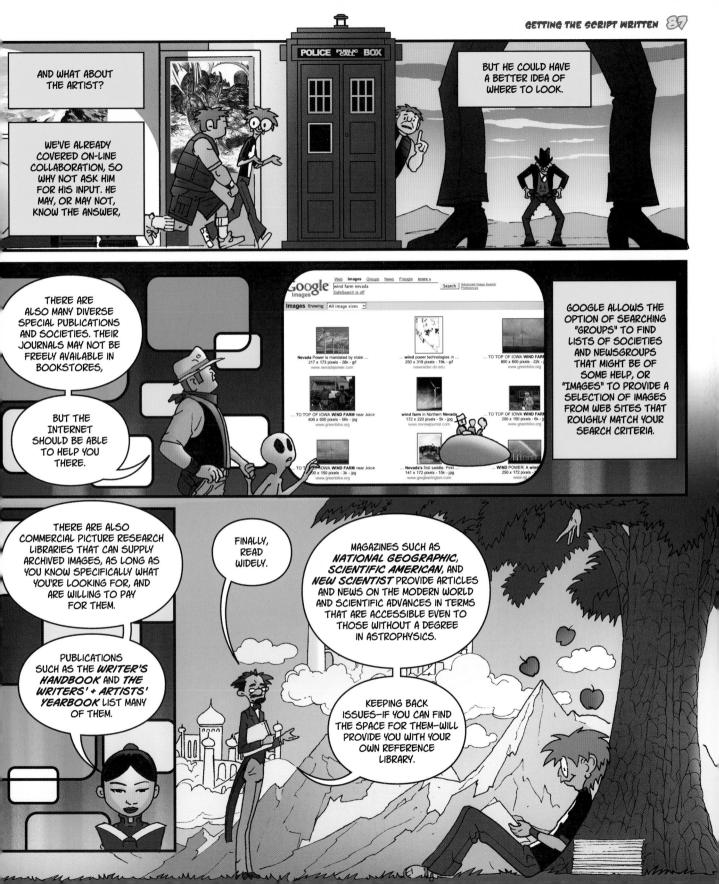

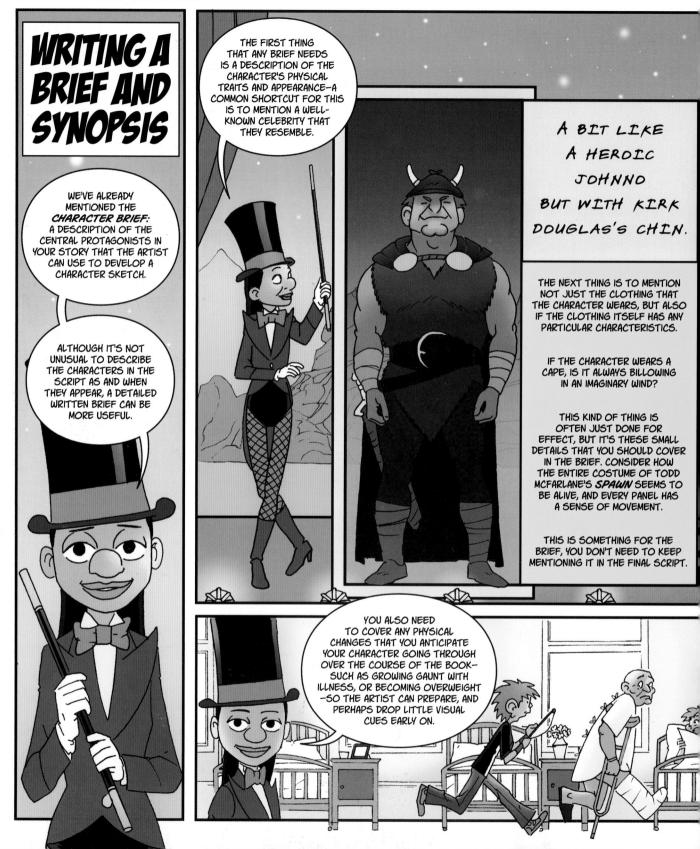

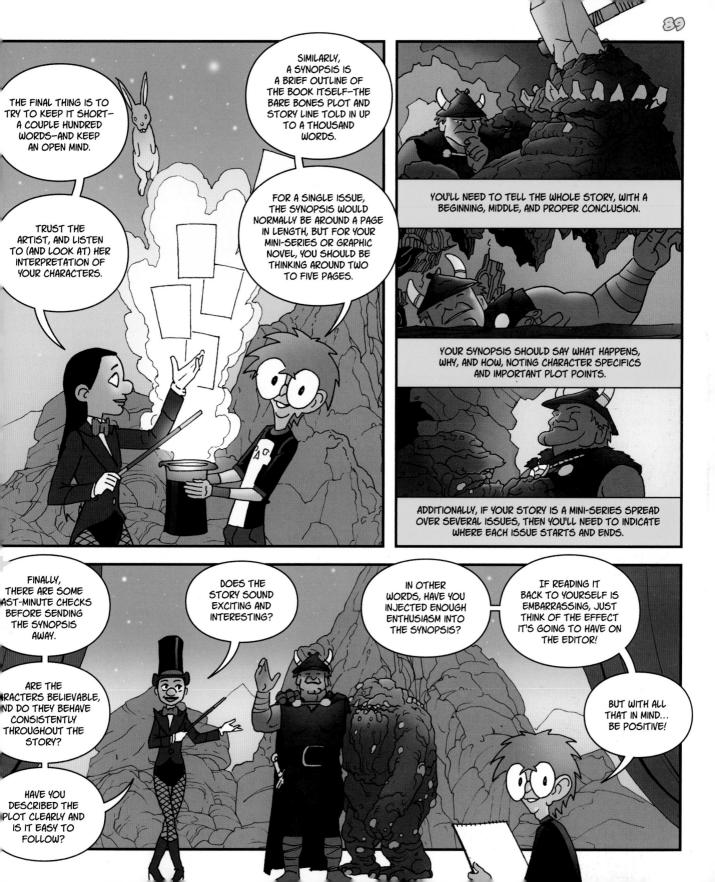

CHAPTER 6

ARTISTIC STYLES 92
ARTISTS' TECHNIQUES 94
BITMAP AND VECTOR SOFTWARE
MAC OR PC? 98
WORKING FROM A BRIEF 100
WORKING FROM A SCRIPT
MOOD 104
STYLES OF ARTWORK
PANEL LAYOUTS 108
FRAMING DEVICES AND CROPS 110
SCANNING IN HAND-DRAWN ARTWORK 112
USE OF LAYERS 114
RGB OR CMYK? 116
CREATING BALLOONS AND LETTERING 118
PLACING TYPOGRAPHY120

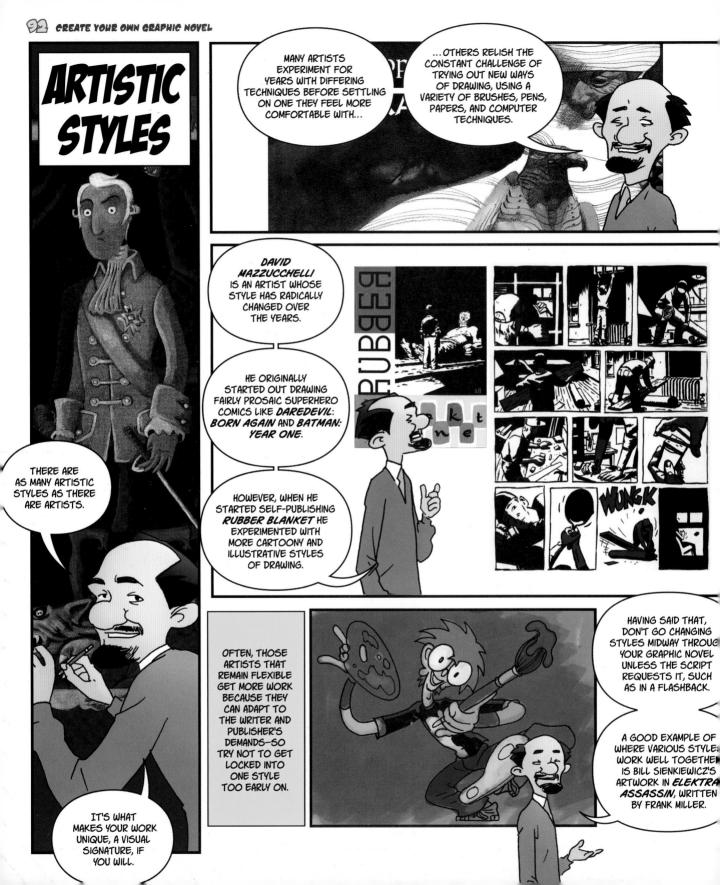

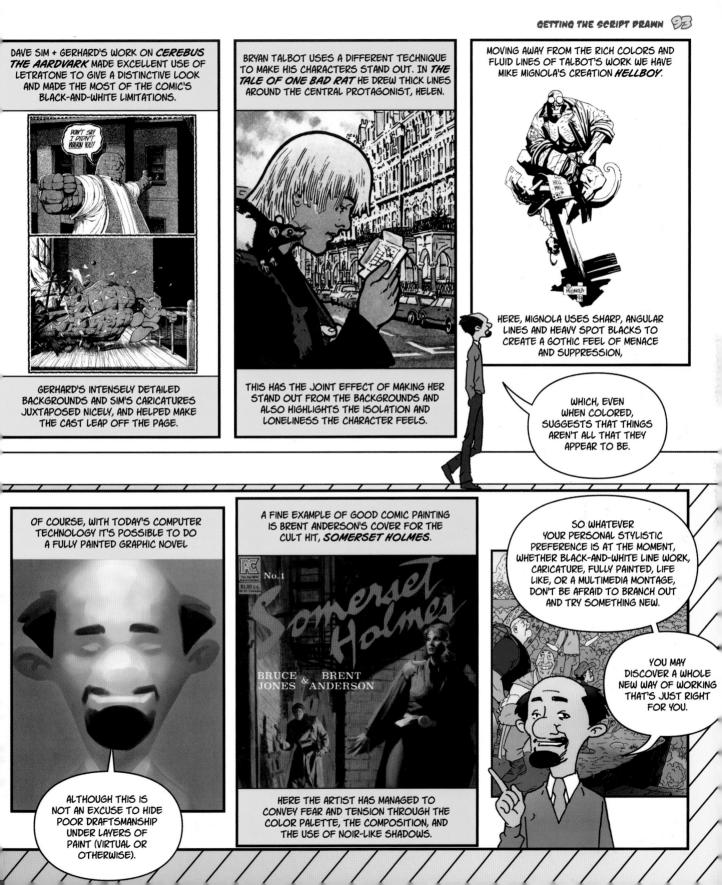

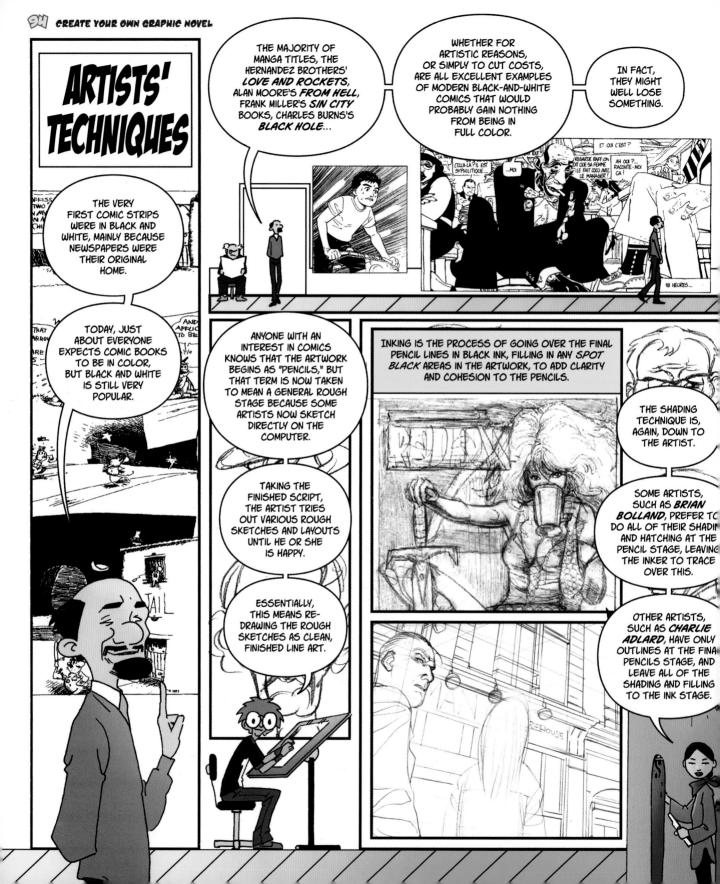

GETTING THE SCRIPT PRAWN

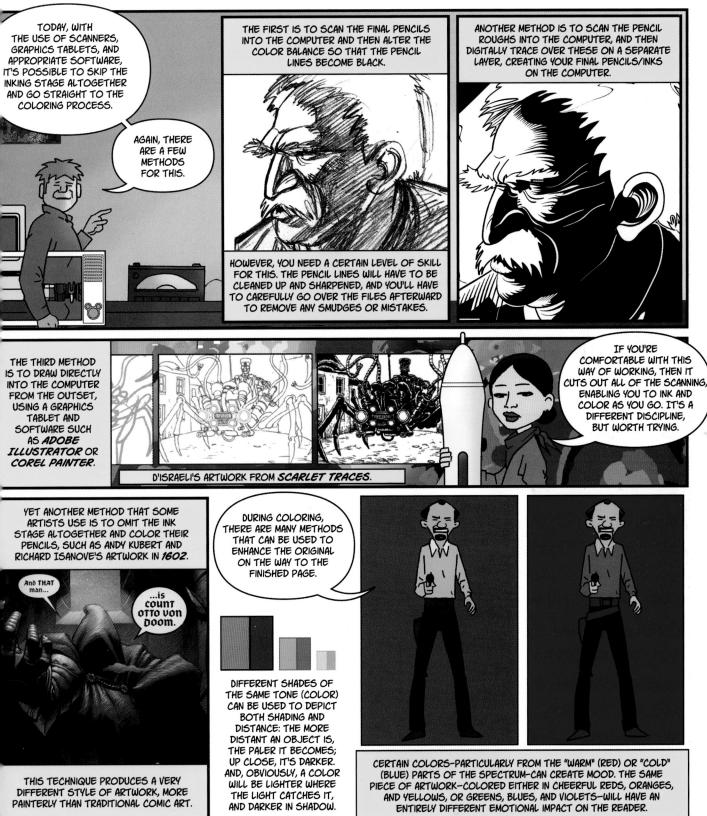

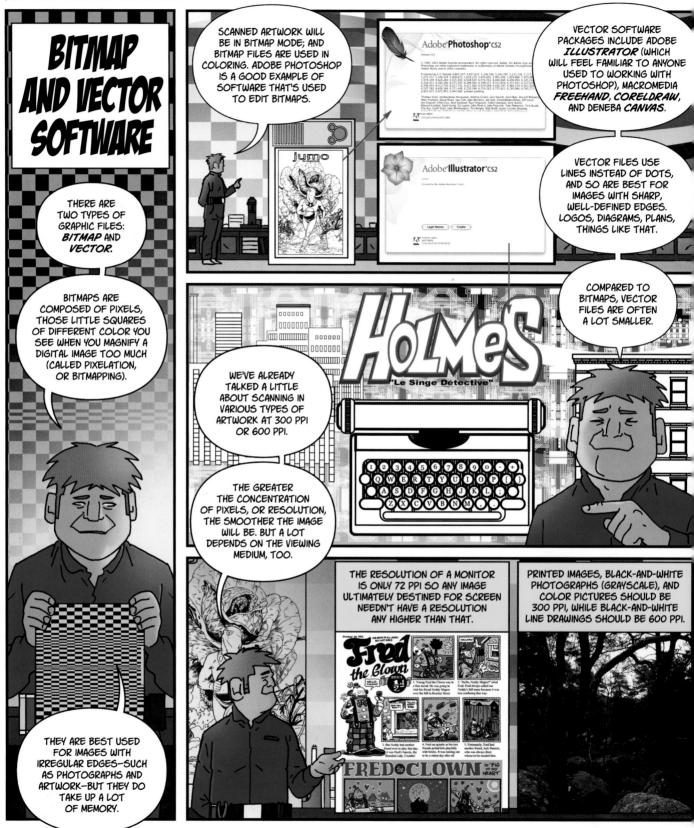

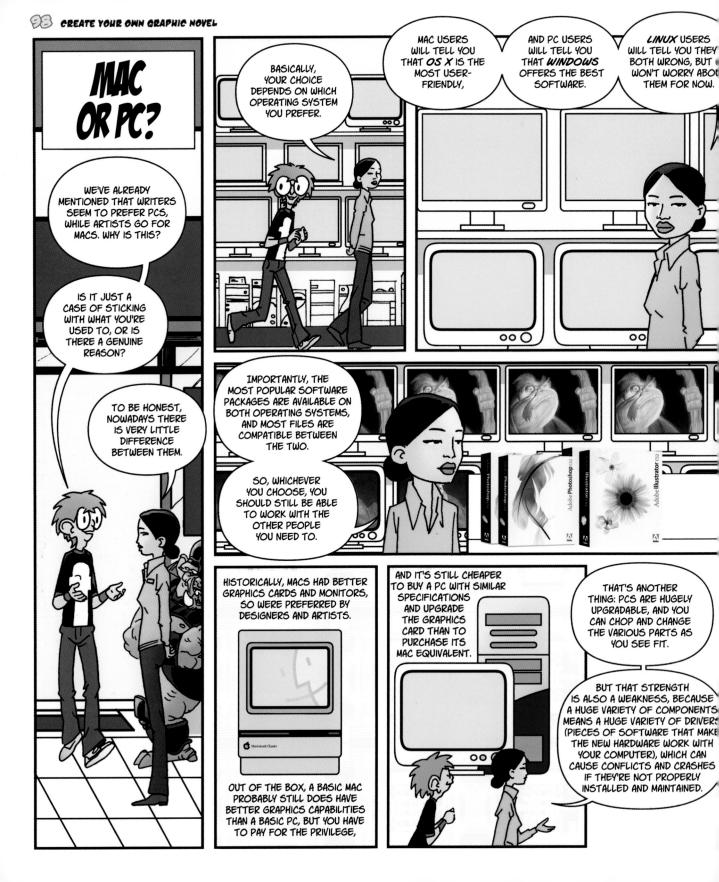

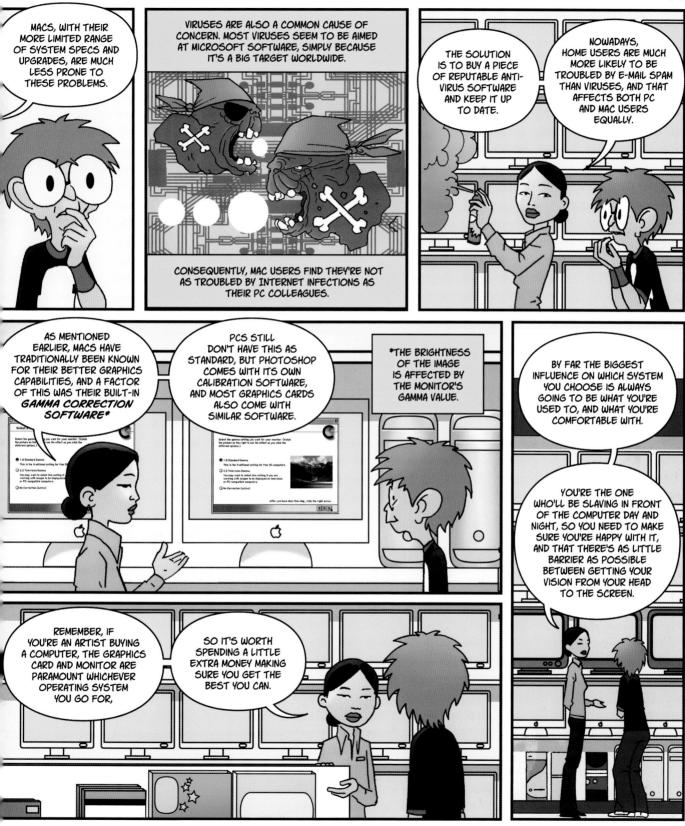

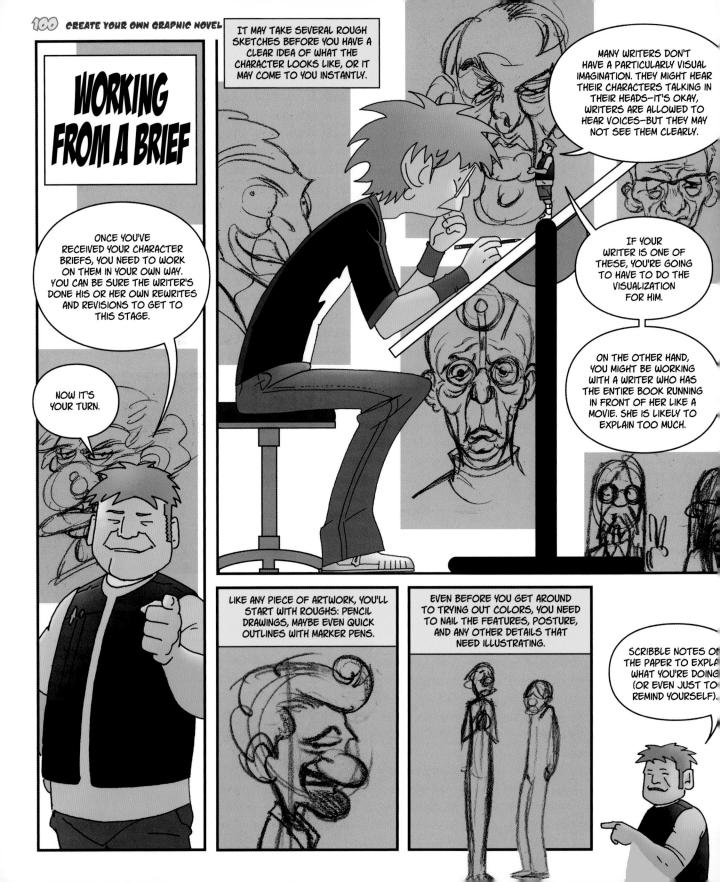

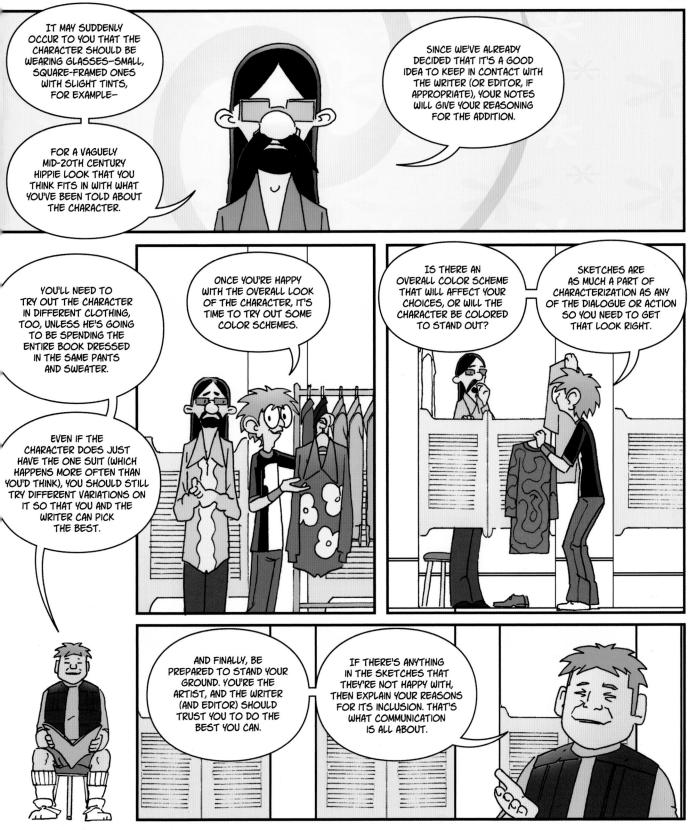

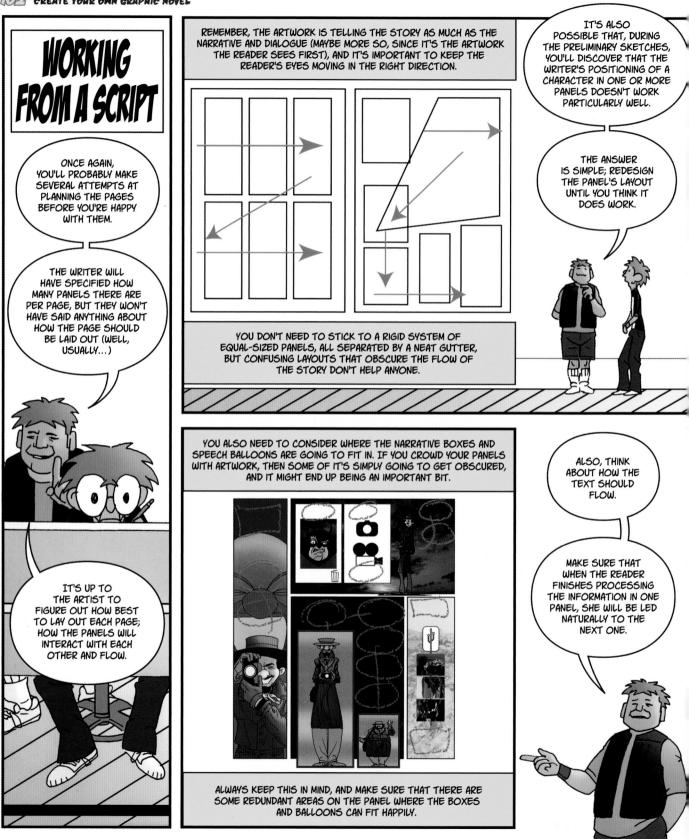

GETTING THE SCRIPT PRAWN

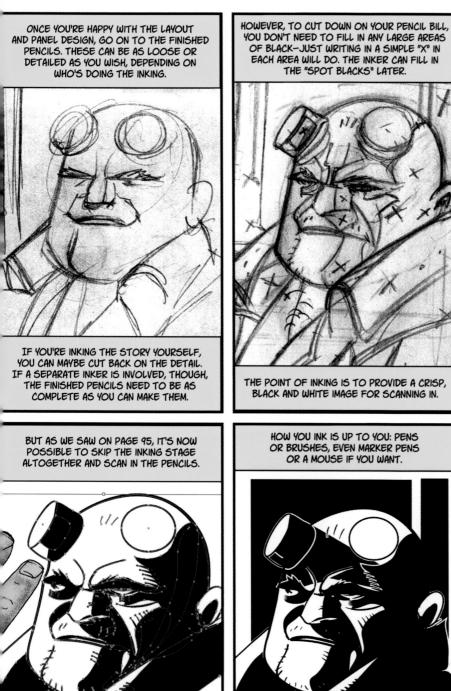

THE MEDIUM DOESN'T MATTER AS LONG

AS THE STORYTELLING IN THE FINISHED

PRODUCT IS CLEAR AND UNDERSTANDABLE.

BEFORE THE ADVENT OF DIGITAL TECHNOLOGY, THE CAMERAS USED FOR CAPTURING ARTWORK DIDN'T GET A PARTICULARLY CLEAN IMAGE FROM PENCILS REMEMBER THE POOR REPRODUCTIONS YOU'D GET FROM A PHOTOCOPIER WITH ANYTHING THAT WASN'T PURE BLACK AND WHITE? DON'T CONFUSE CLEAN INKS WITH CLEAN LINES: YOU NEED TO MAKE SURE THE INKS CONTAIN ONLY THE LINES THAT YOU WANT IN THE FINISHED PIECE, BUT THE LINE STYLE CAN BE AS "MESSY" AS YOU WANT-BILL SIENKIEWICZ'S ART IS A GOOD EXAMPLE.

WITH MODERN SCANNERS, YOU CAN CHOOSE WHETHER YOU WANT TO INK YOUR PENCILS BEFORE SCANNING THEM, OR TO SCAN THE PENCILS AND THEN "INK" DIGITALLY.

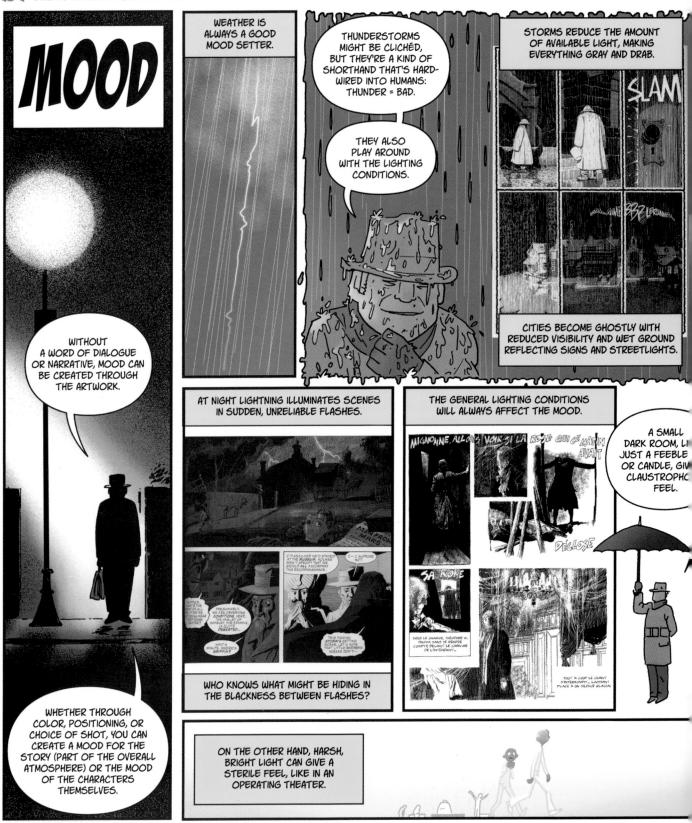

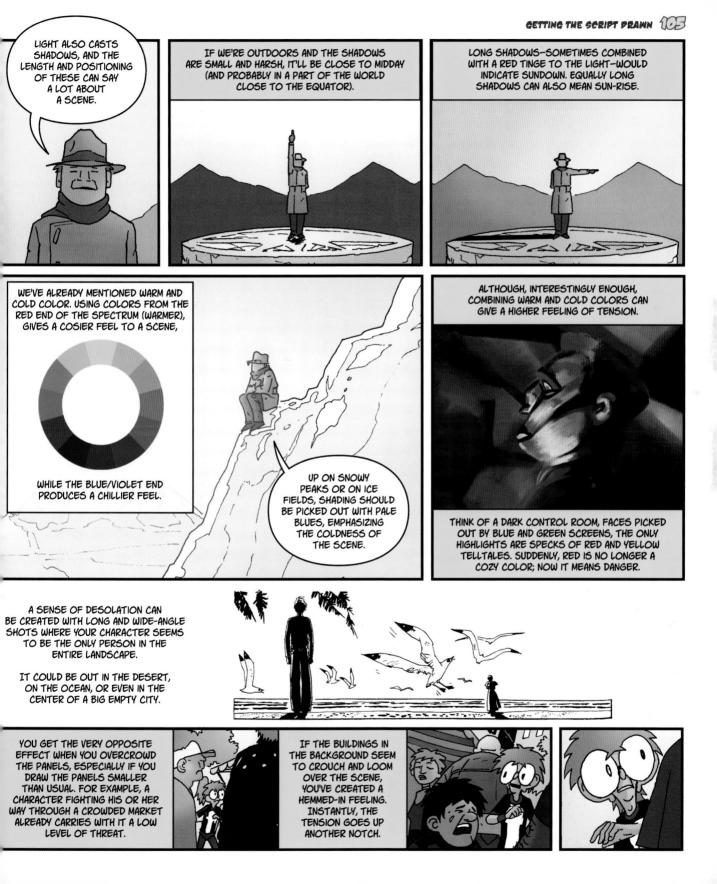

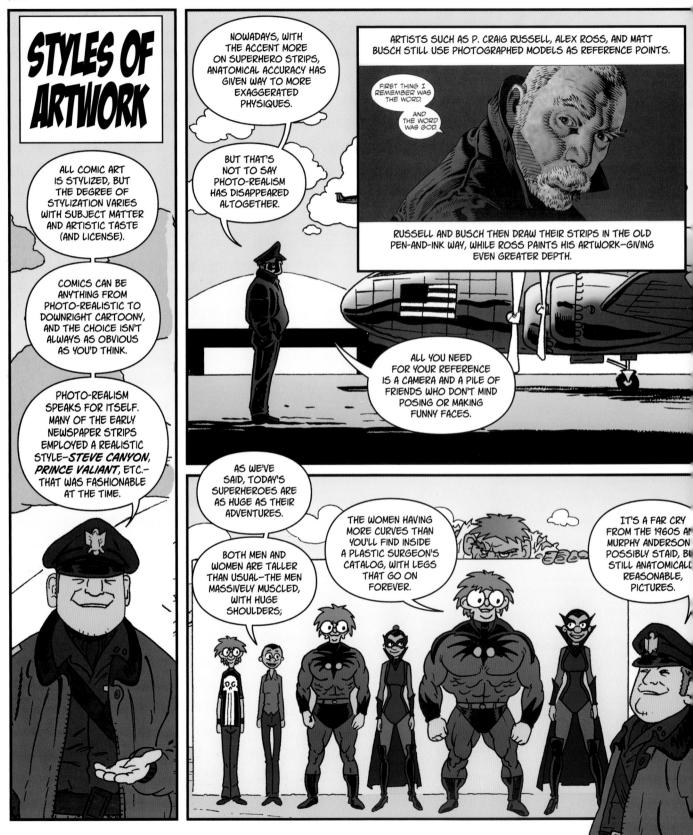

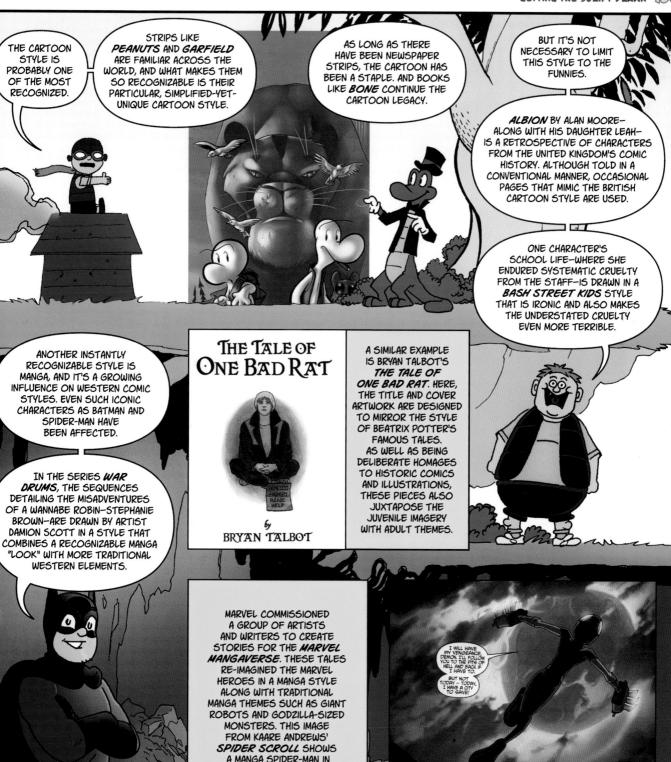

A MANGA SPIDER-MAN IN A TYPICAL WESTERN SUPER-HERO POSE.

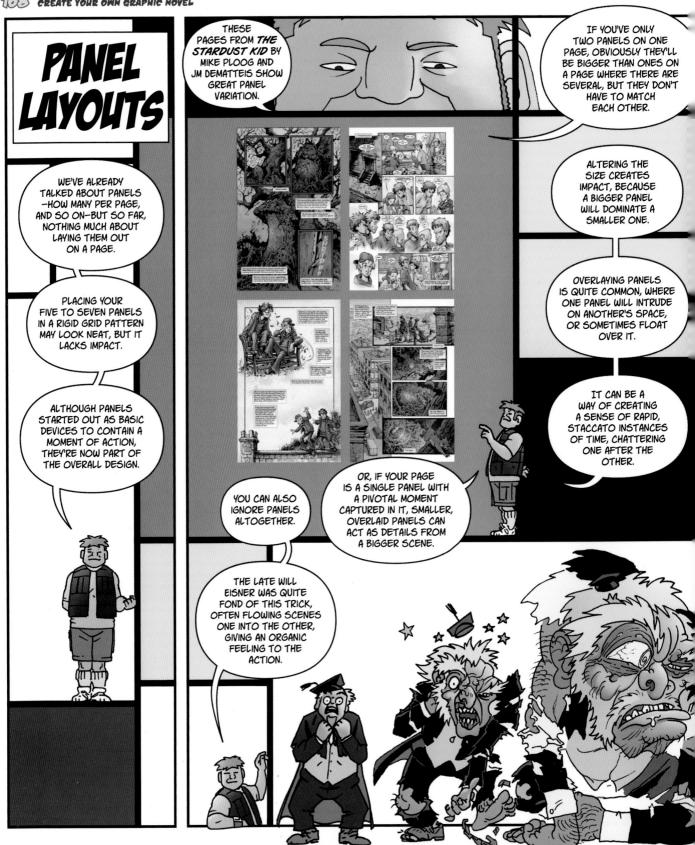

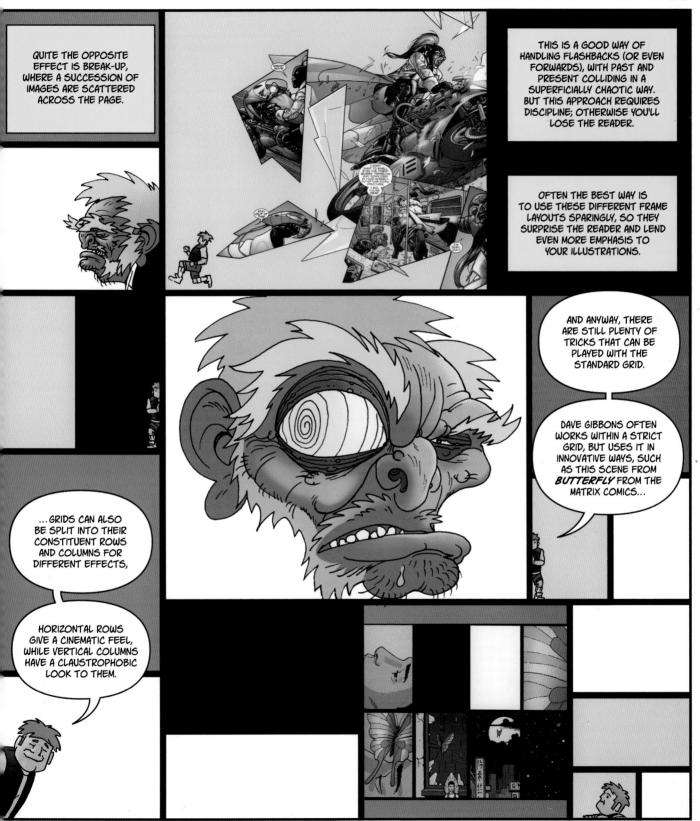

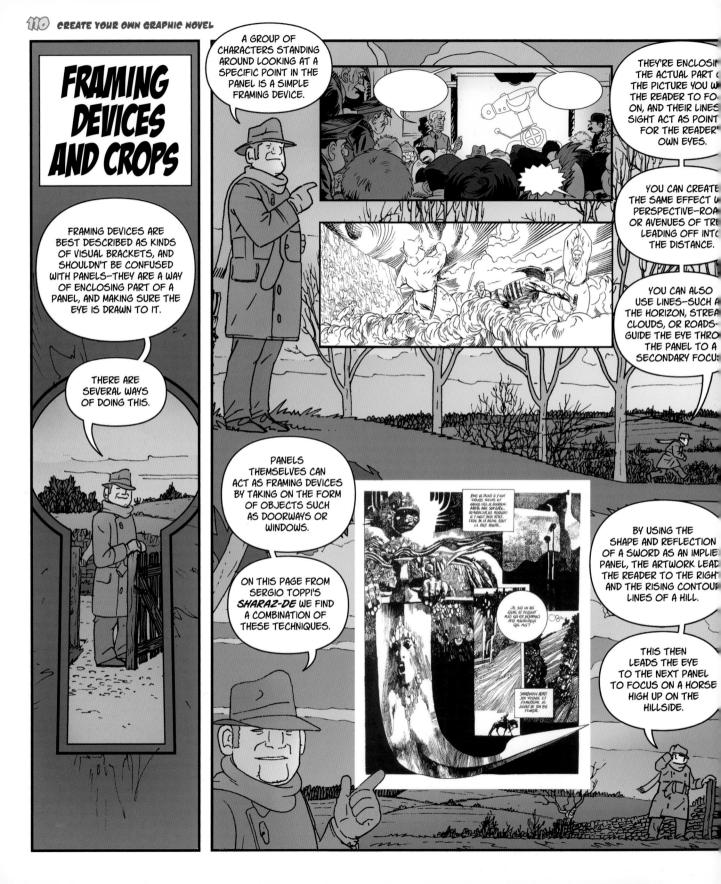

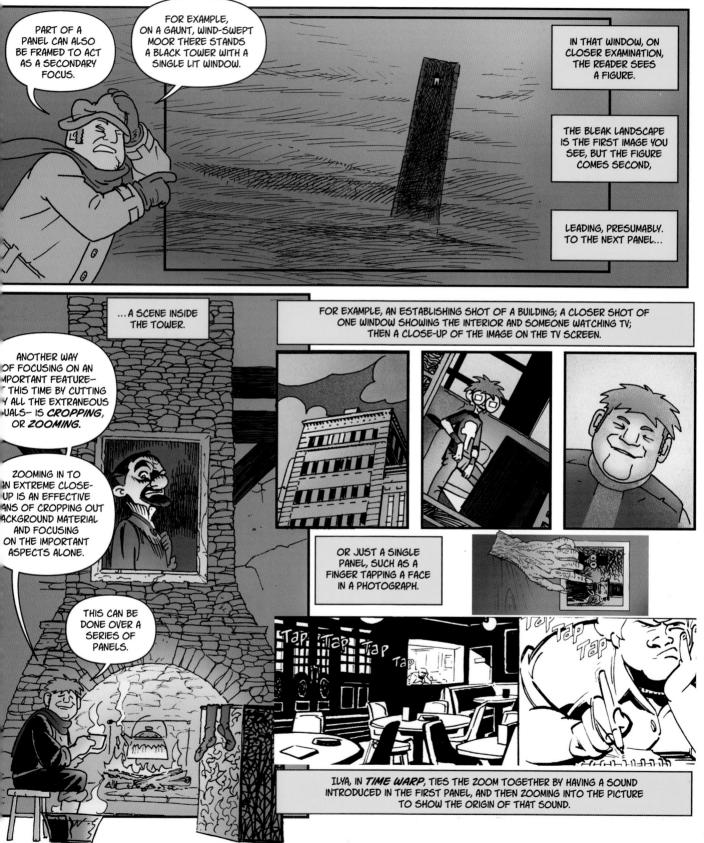

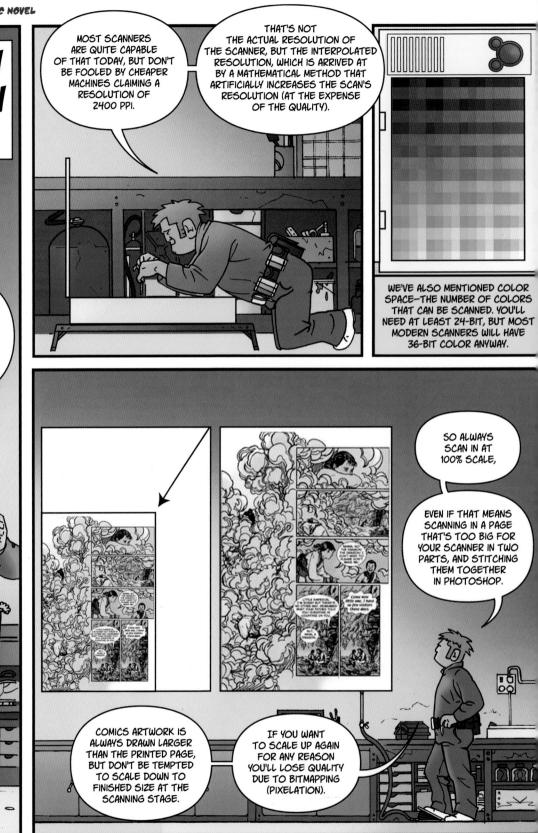

YOU CAN

THEN ADJUST THE

BLACKS AND WHITES

USING PHOTOSHOP'S

LEVELS MENU.

INKED ARTWORK WILL

HAVE CLEARLY DEFINED LINES, BUT

PENCILS ARE OFTEN NOT SO CLEAR,

AND THERE MAY BE MORE THAN ONE

STROKE TO CHOOSE FROM. YOU NEED TO TIGHTEN THEM UP AS MUCH AS POSSIBLE.

38

THEN SIMPLY

USE THE LASSO, PAINT

BUCKET, PENCIL, AND LINE TOOLS TO TIDY UP

ANY REMAINING LINES.

Sherwood

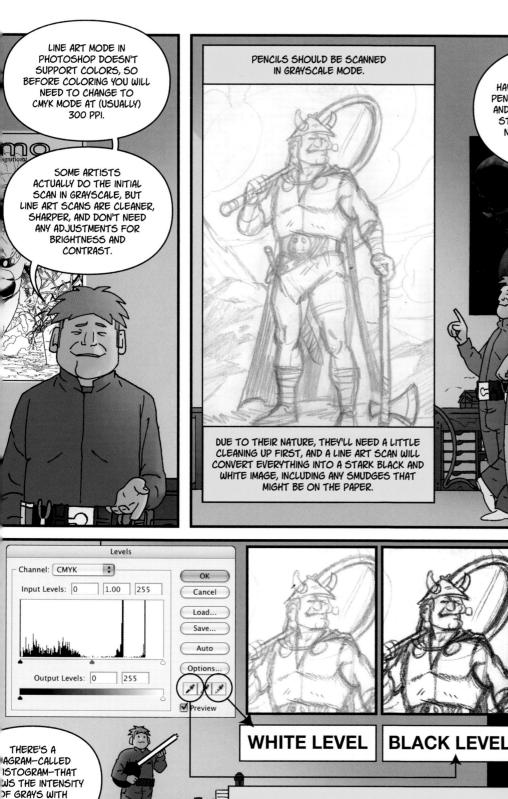

1

SPIKES.

P

WITH A LITTLE PRACTICE, YOU WILL FIND YOU CAN CLEAR AWAY MOST OF THE LIGHTER GRAYS (MAKING THE BACKGROUND "PAPER" WHITE) AND BLACKEN UP THE STRONGEST OF THE PENCIL LINES.

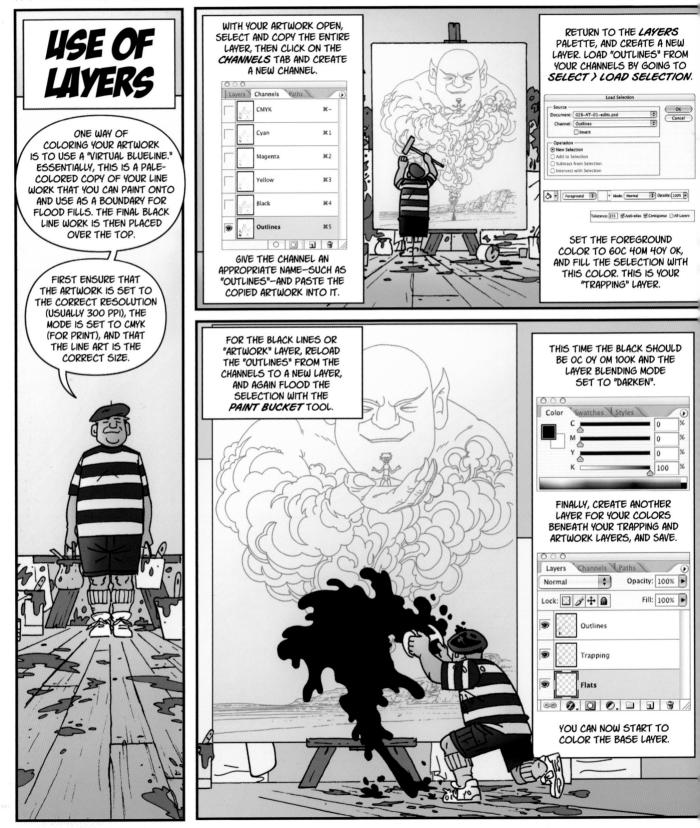

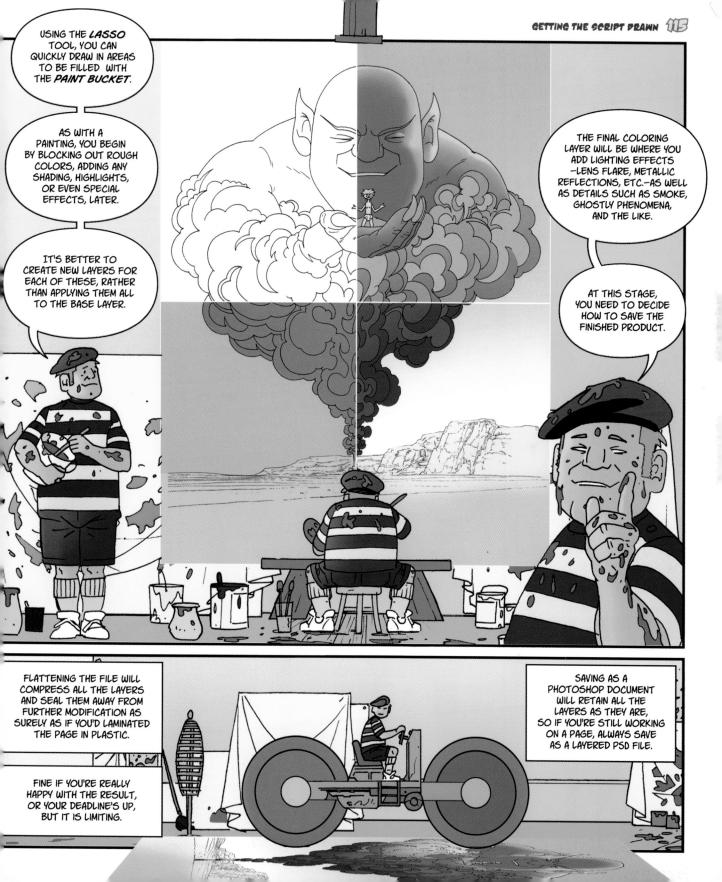

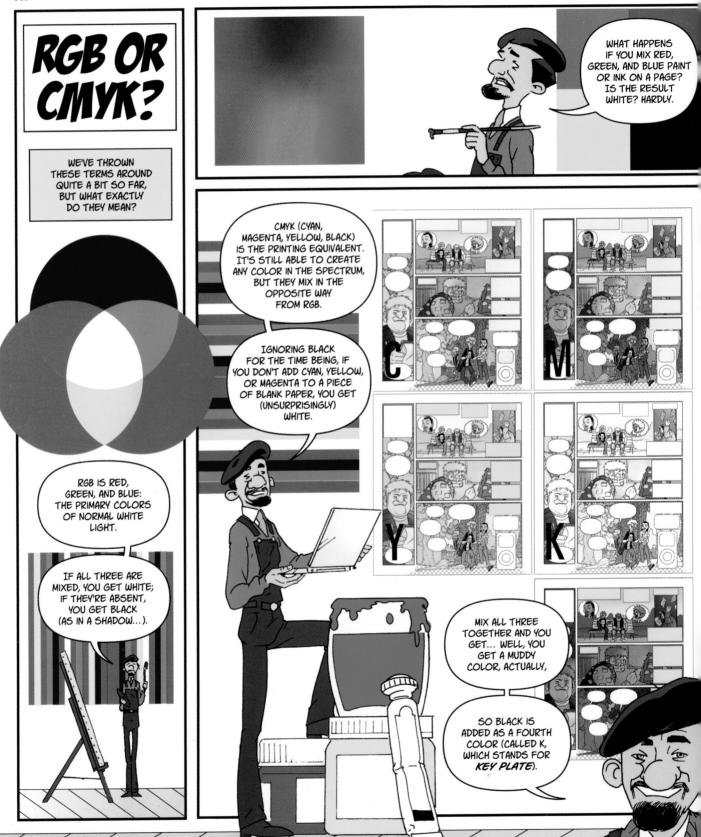

GETTING THE SCRIPT PRAWN

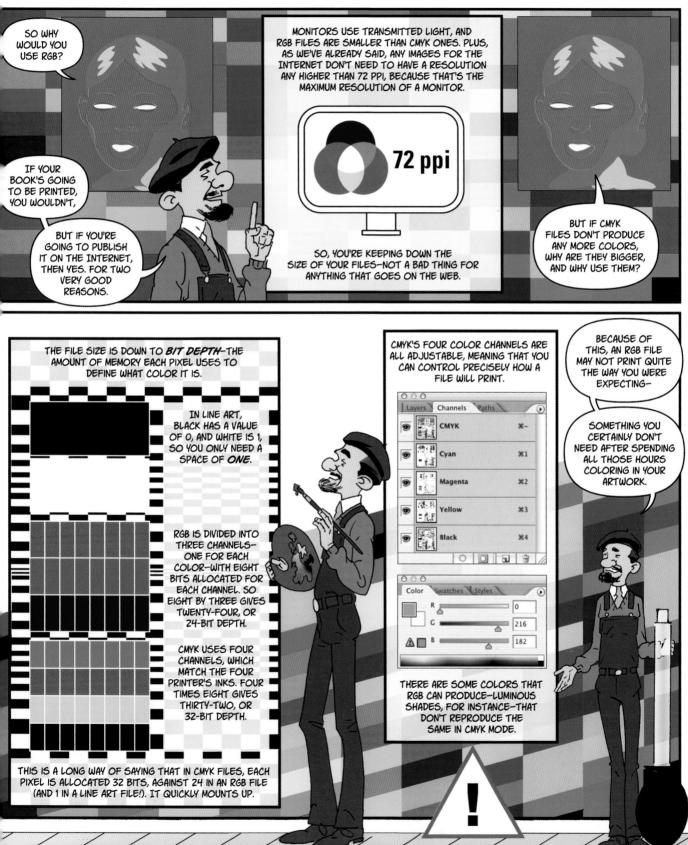

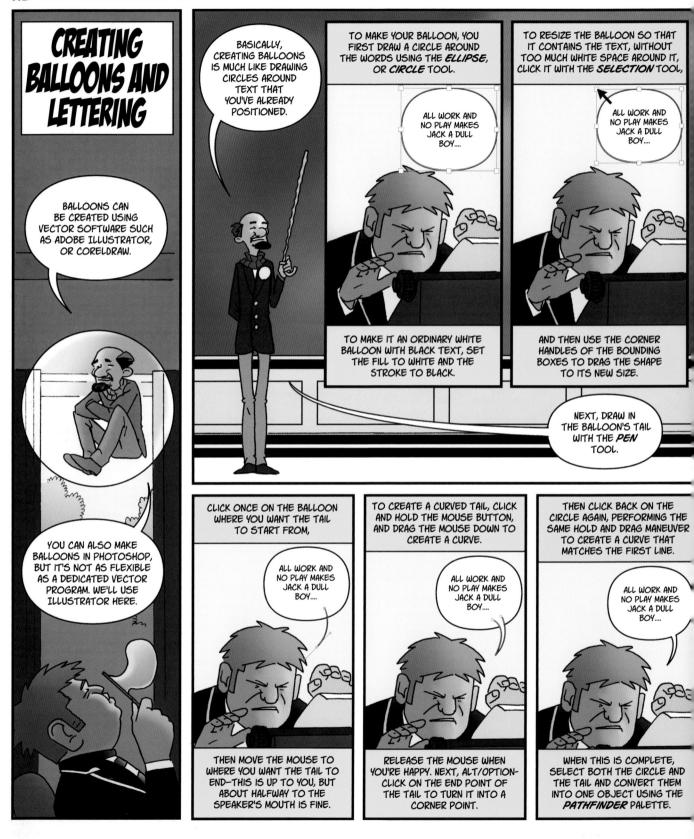

GETTING THE SCRIPT PRAWN

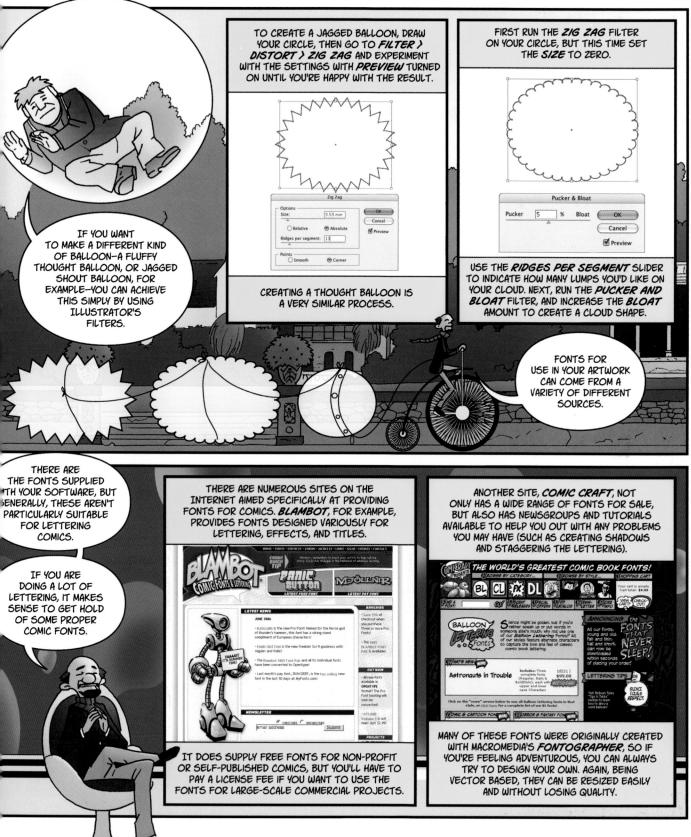

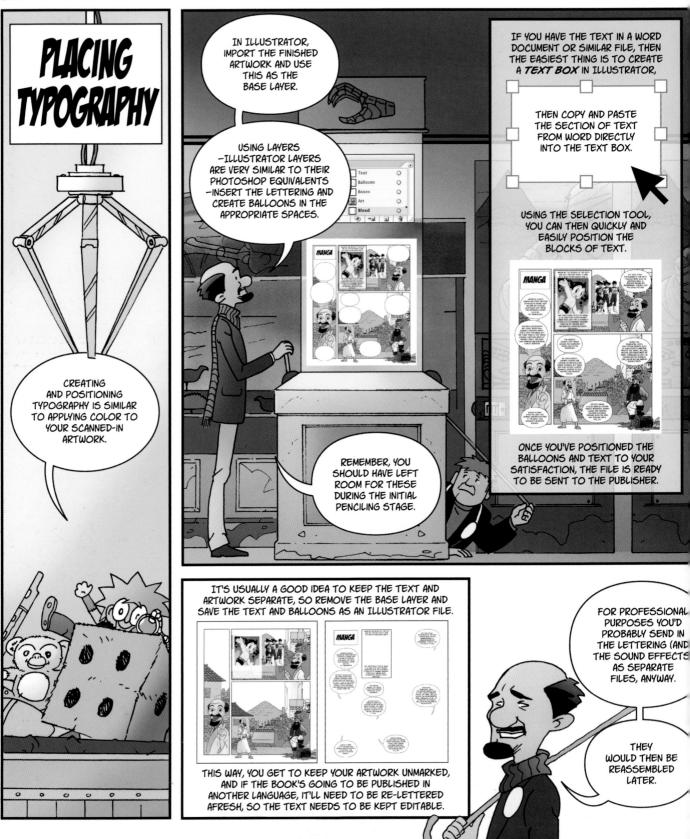

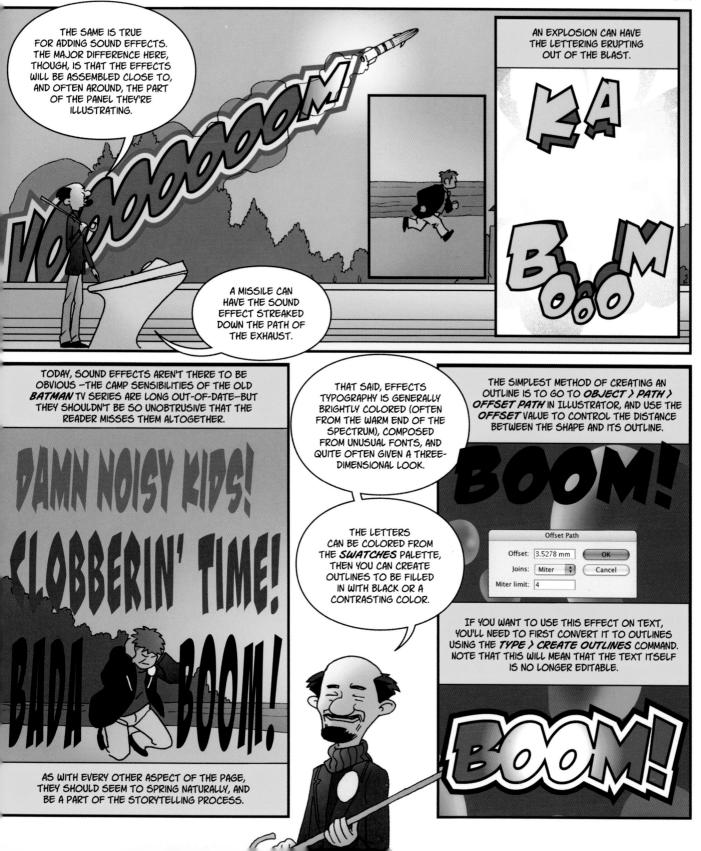

CHAPTER 7

THE NEXT BIG THING?	.124
SKETCHING IN 3D	.126
CREATING SOLID BACKGROUNDS	.128
REALISTIC CHARACTERS	.130

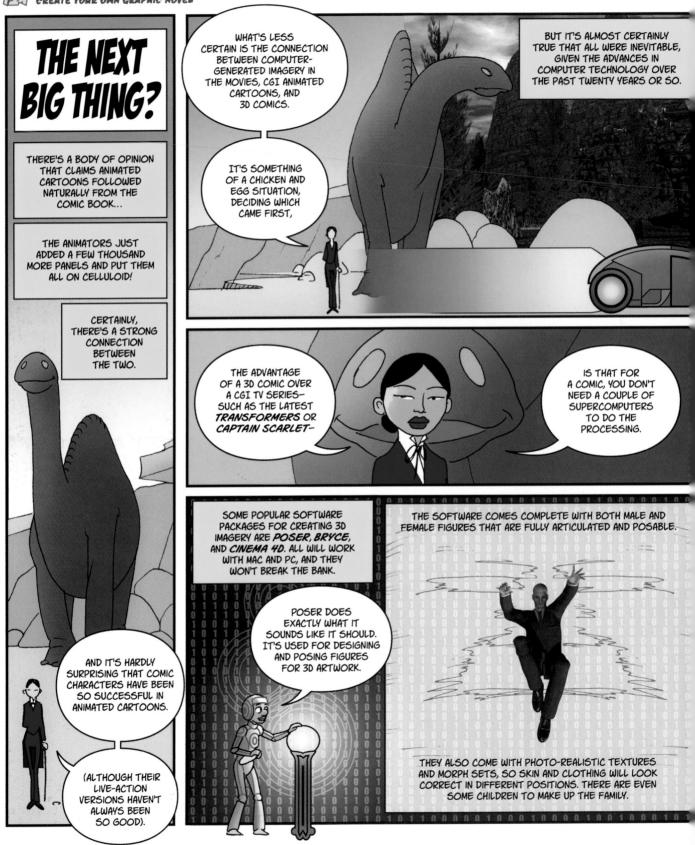

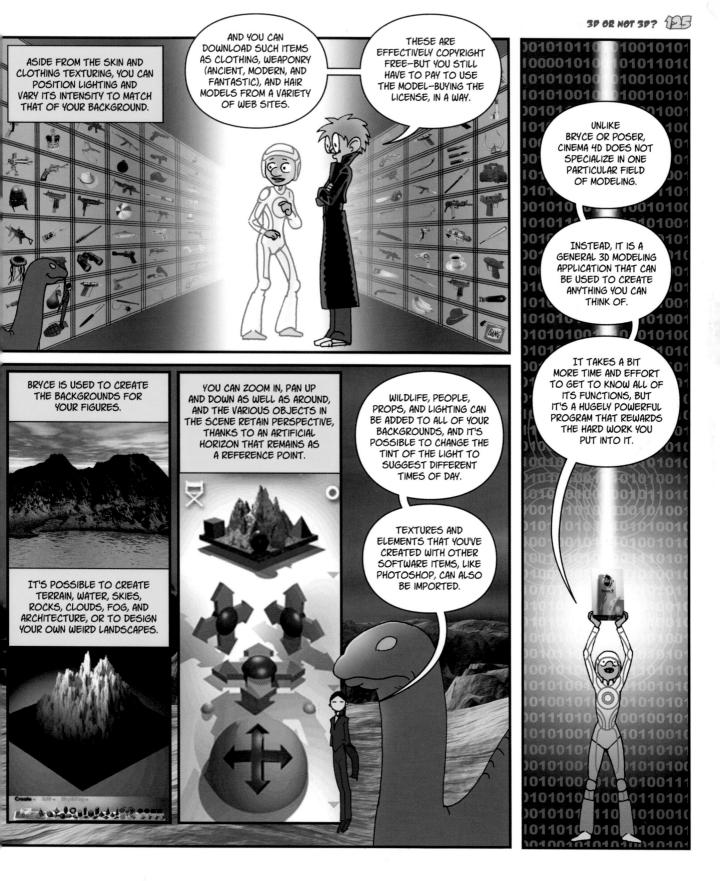

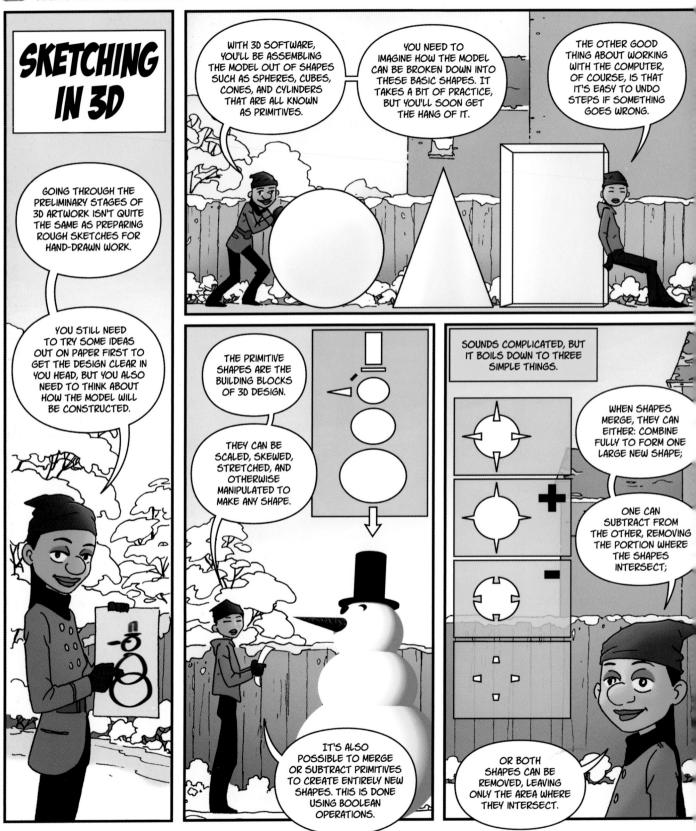

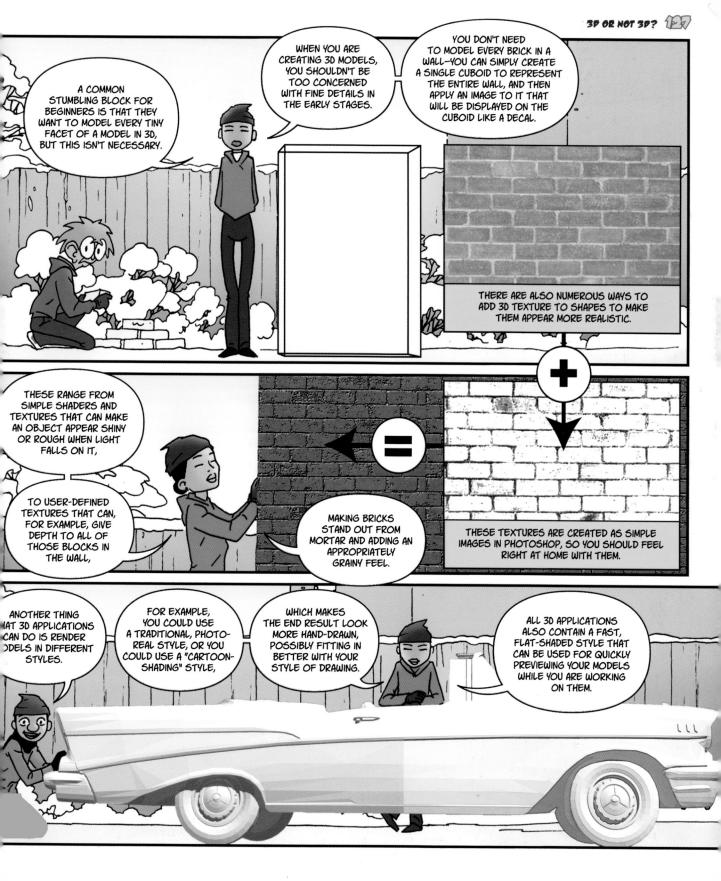

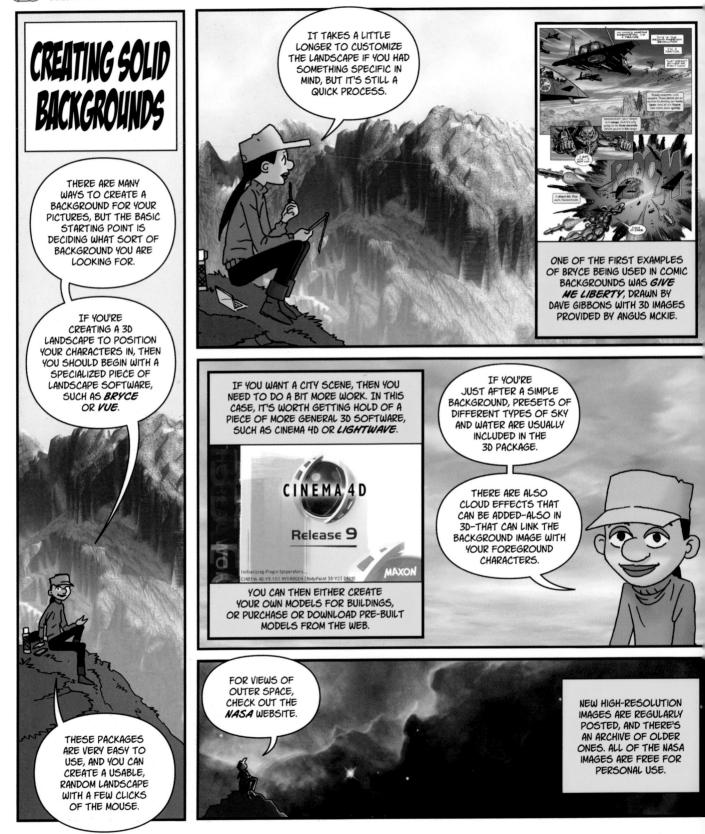

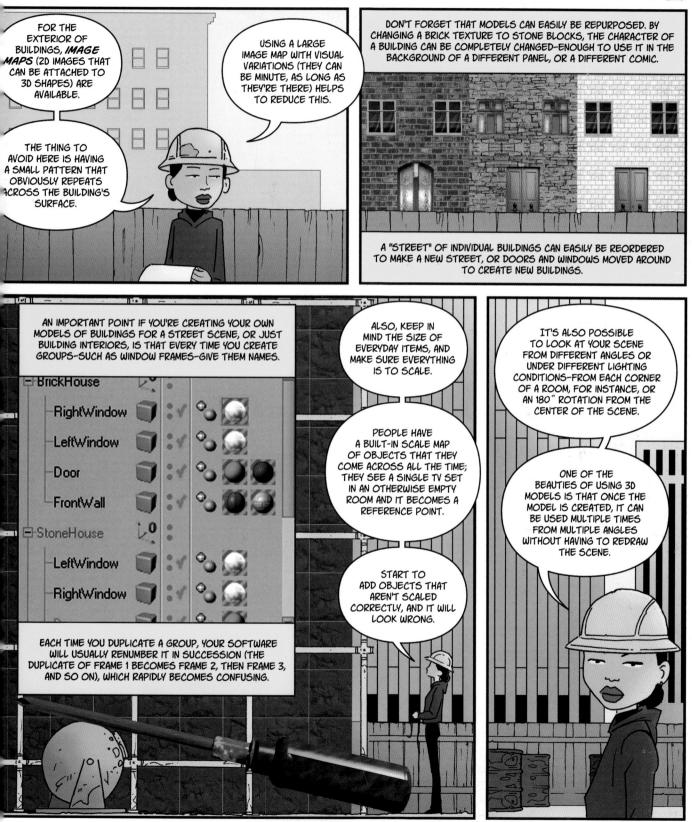

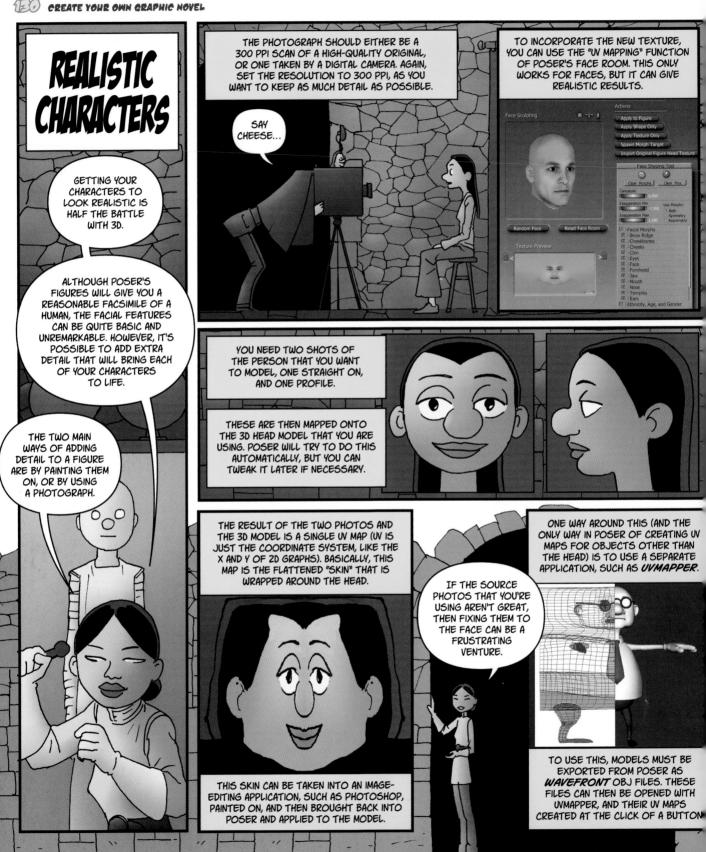

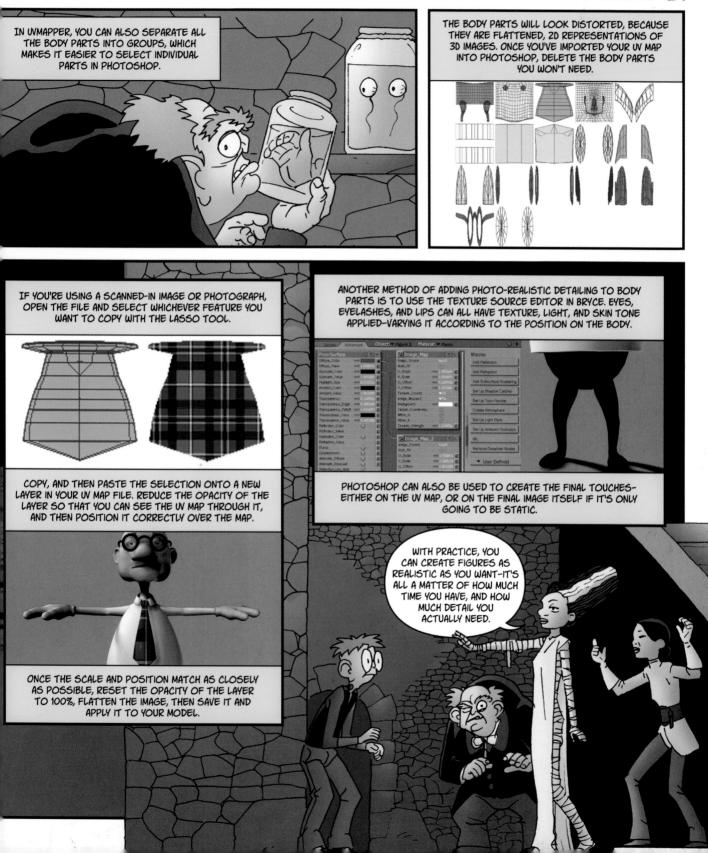

CHAPTER 8

WEB COMICS	134
FLASH!	136
SELF-PUBLISHING	138
PROMOTION AND MARKETING 1	40
THE INTERNET FOR SALES AND PROMOTION	142
BASIC NETWORKING	44
PITCHING TO A PUBLISHER	146

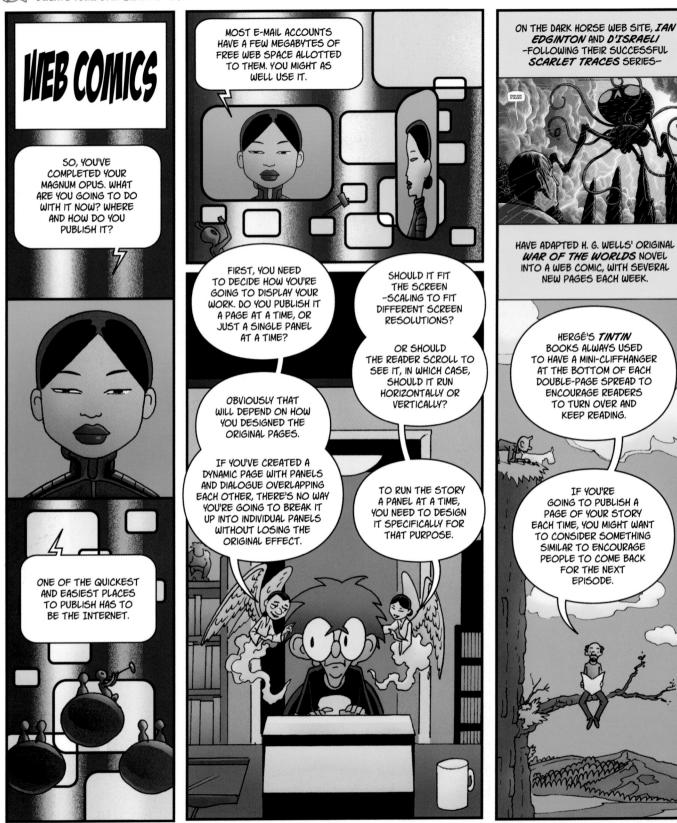

Page 16: Genres and Beyond Update

GARGES SACRES FROM THE AND A SACRES FROM THE ADDRESS A

Browse Link

Genre-&beyond-02.jpg Crime-templatepsd.jpg 037-FP-02_CRNO.psd HTML Files

BUT UNLESS

YOU WANT YOUR ENTIRE

STORY TO BE OUT THERE

IN A COUPLE OF WEEKS, IT'S

NOT THE MOST REALISTIC

OF SCHEDULES.

4

11

18

25

ARKEYOUR OWN

vious Pa

Set Image Mag

rea Lini

Wrap to Co

Detect Rollover Im

GRAPHIC NOVEL

una no

3

10

17

24

31

2

9

16

23

30

WHICH RAISES THE NEXT POINT: WHAT IS YOUR PUBLISHING SCHEDULE GOING TO BE-DAILY, WEEKLY, OR MONTHLY? am

ANOTHER FACTOR TO CONSIDER IS HOW MUCH WEB SPACE YOUR PAGES WILL TAKE UP. REMEMBER, YOU'RE GOING TO HAVE TO LEAVE EARLIER EPISODES ON YOUR WEB SITE FOR NEW READERS TO CATCH UP. 건

EVEN AN AVERAGE MONTHLY COMIC BOOK RUNS TO TWENTY-TWO PAGES, SO KEEPING FILE SIZE DOWN-USING JPEGS AND NO MORE THAN 72 PPI RESOLUTION-STILL REMAINS AN IMPORTANT CONSIDERATION.

1

8

15

22

29

LINKING ALL

THESE SEPARATE PAGES

SO A READER CAN JUMP TO

WHICHEVER EPISODE THEY

7

14

21

28

6

13

20

THERE ARE MANY

WEB COMIC SITES

THAT PUBLISH DAILY GAG

STRIPS-JUST LIKE

THE NEWSPAPERS.

IT DOESN'T MATTER IF YOU USE A THUMBNAIL IMAGE, A GRAPHICAL BUTTON THAT COMES PACKAGED WITH THE SOFTWARE, OR A TEXT LINK.

YOU SIMPLY HIGHLIGHT THE IMAGE OR TEXT, CHOOSE INSERT HYPERLINK, OR A SIMILAR COMMAND, AND SELECT THE PAGE YOU WISH TO LINK TO.

5

12

19

26

WHEN YOUR PAGES ARE PUBLISHED ON THE INTERNET, THEIR APPROPRIATE ADDRESSES (OR URLS) WILL BE AUTOMATICALLY CREATED.

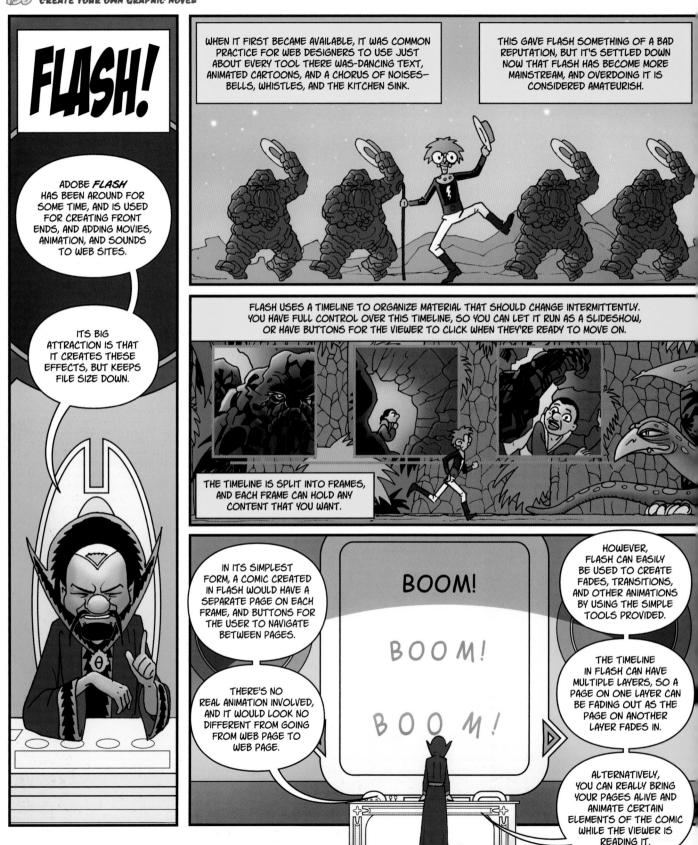

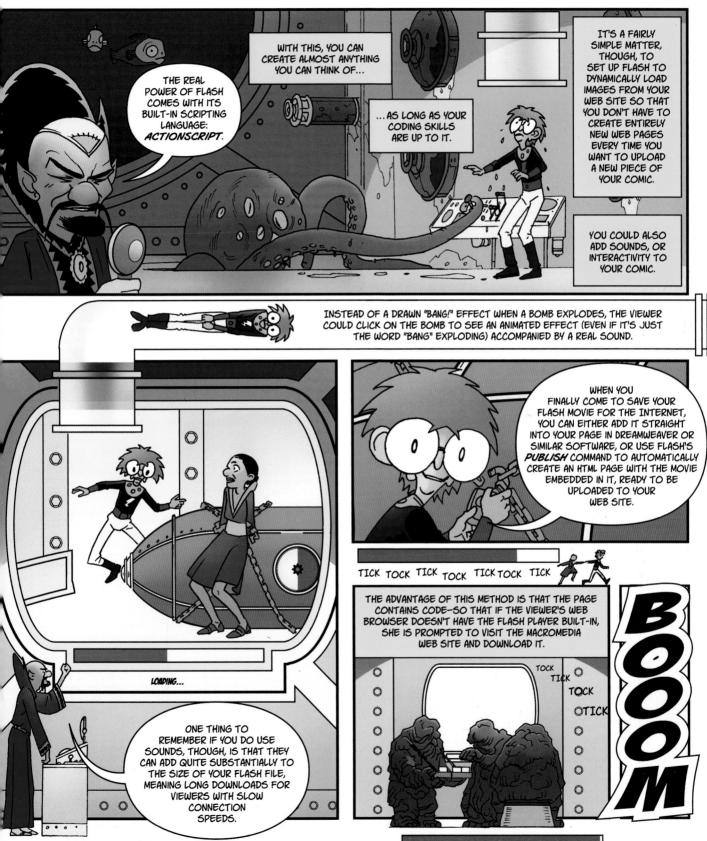

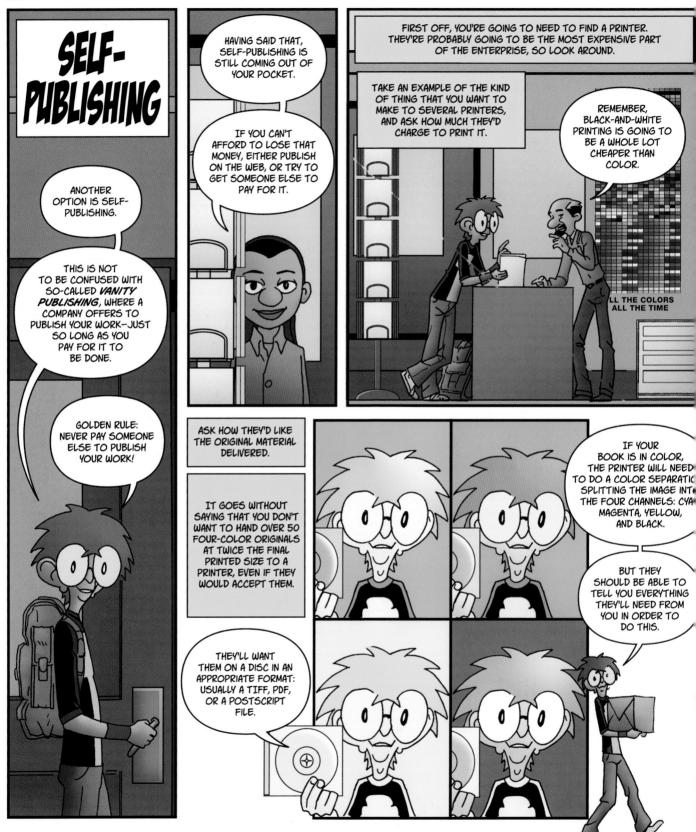

PUBLISH AND BE PAZZLED!

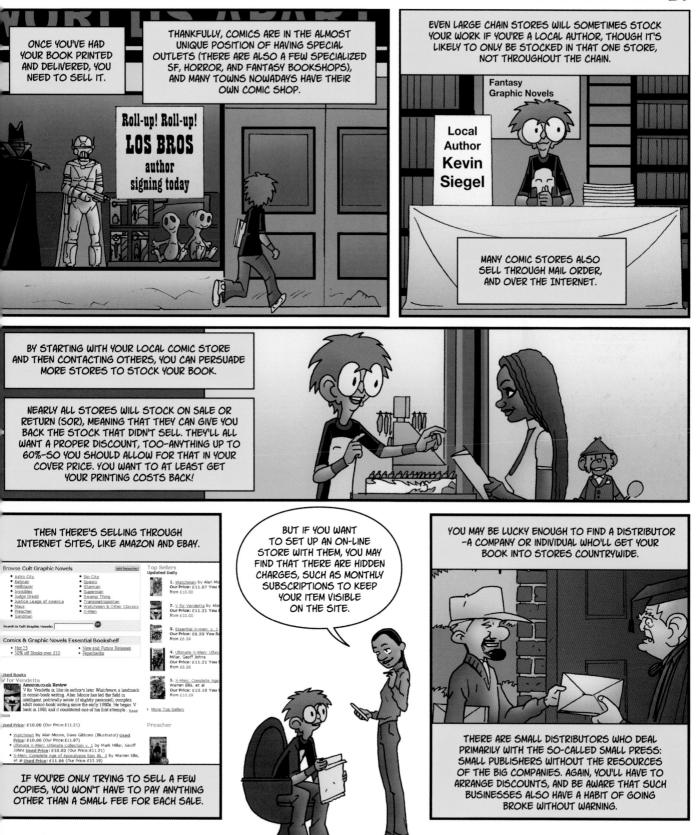

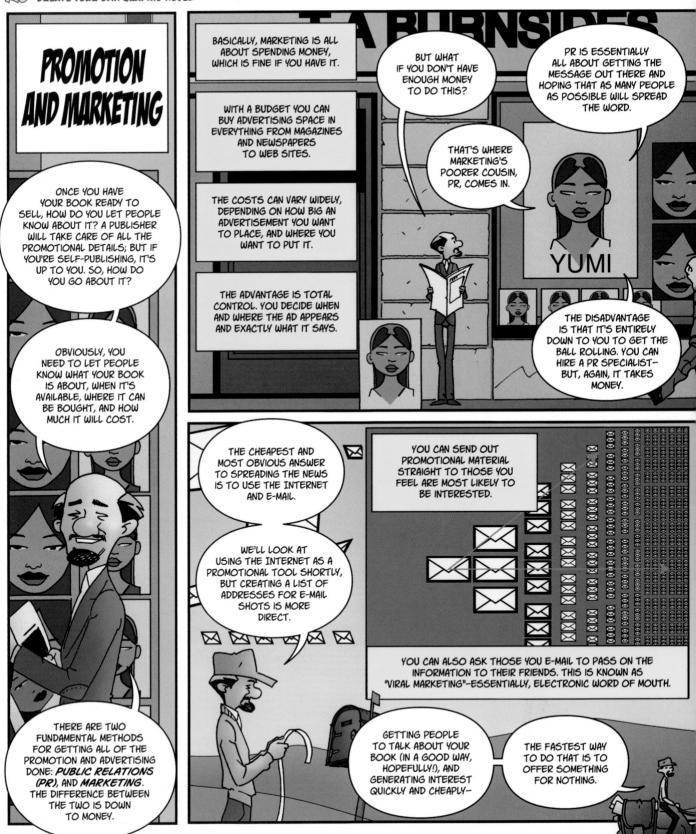

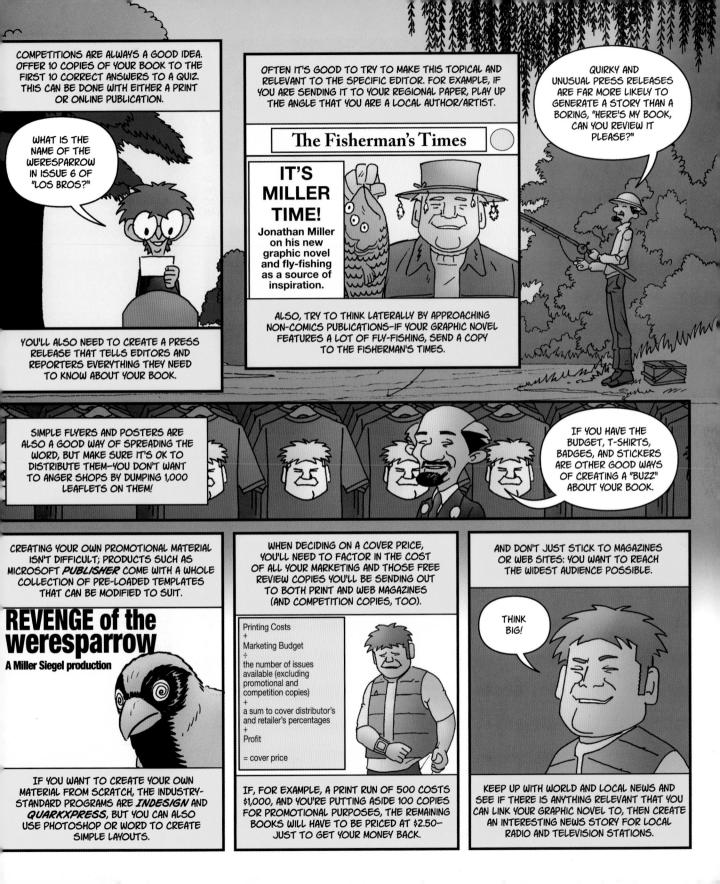

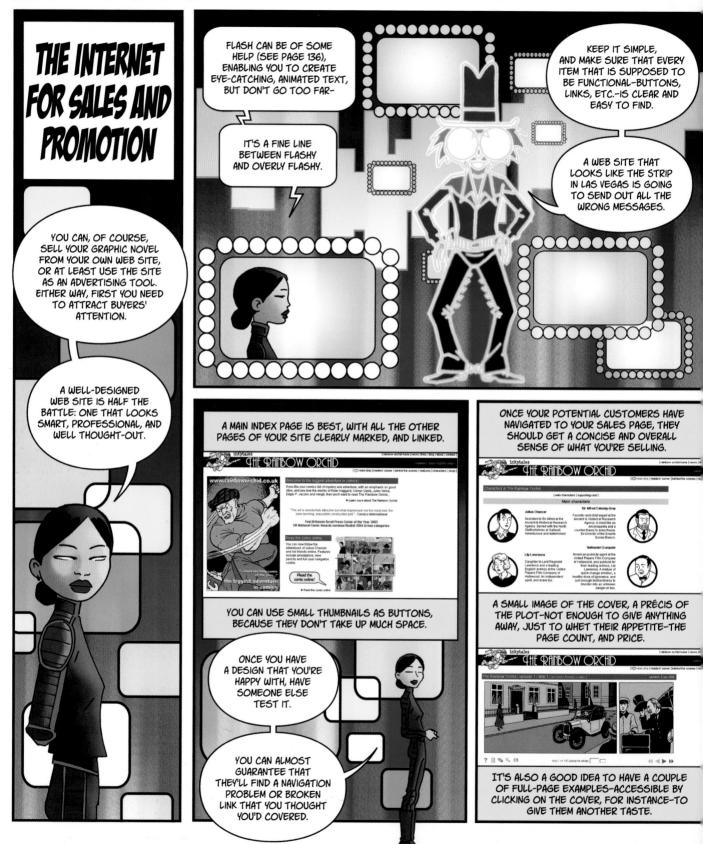

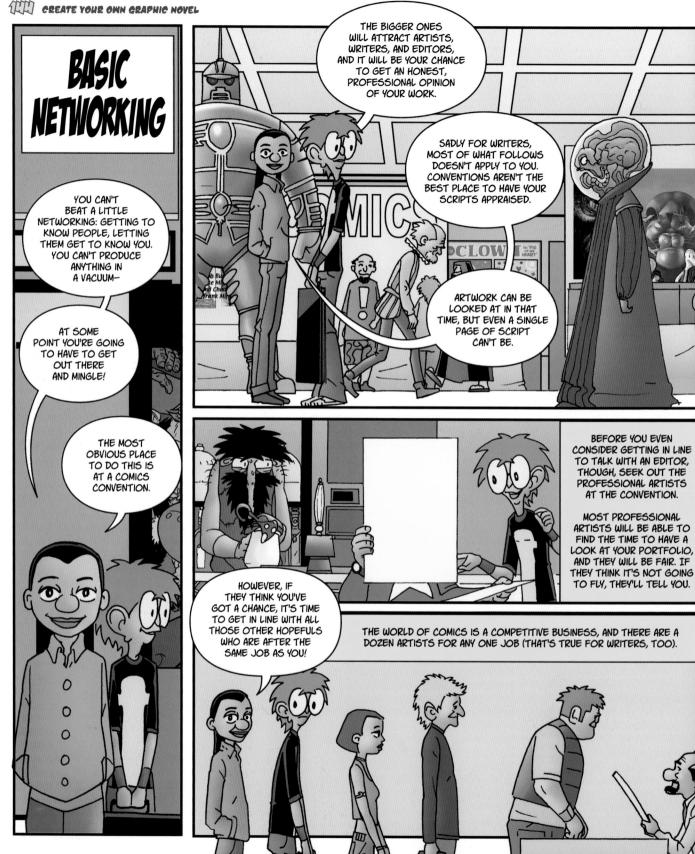

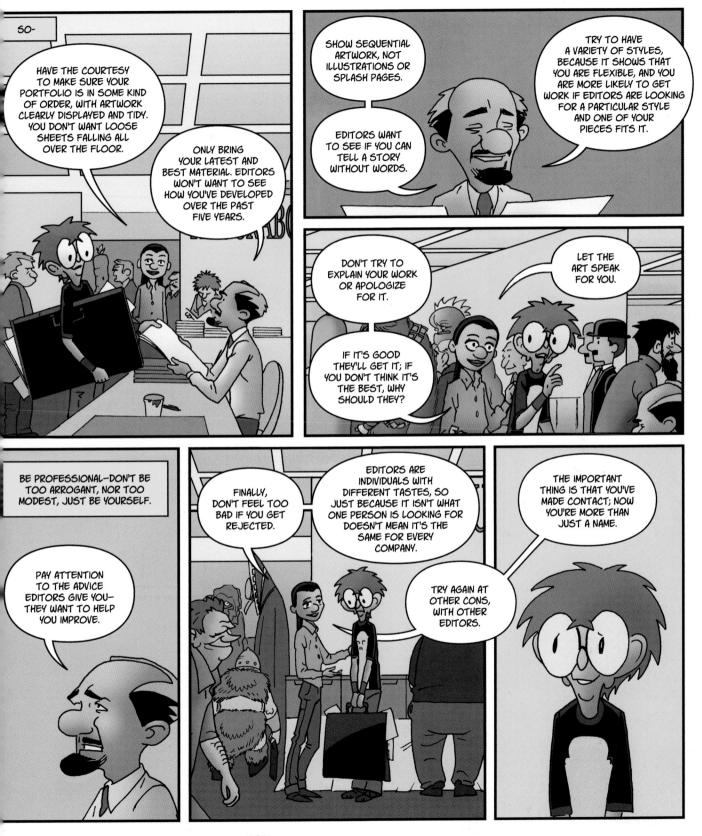

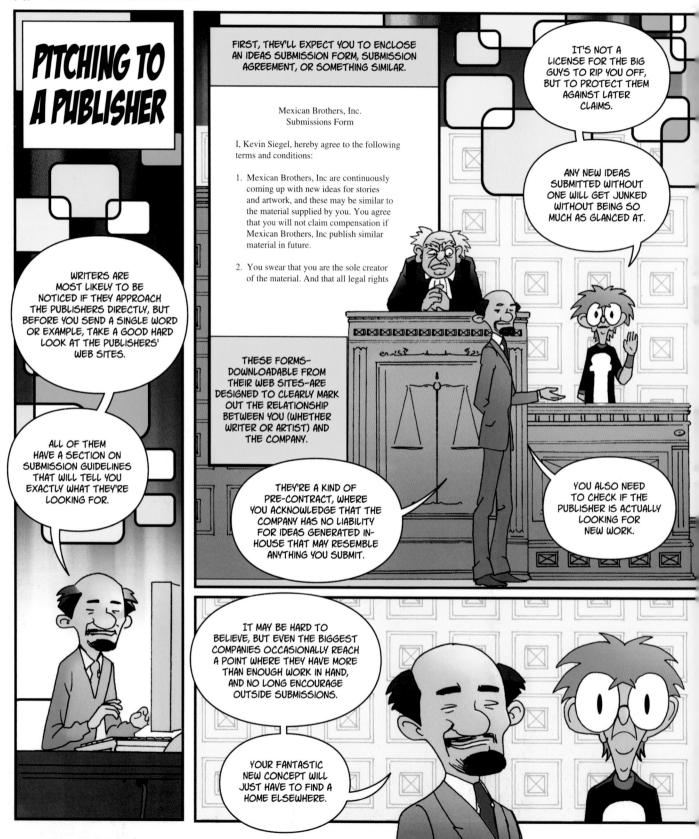

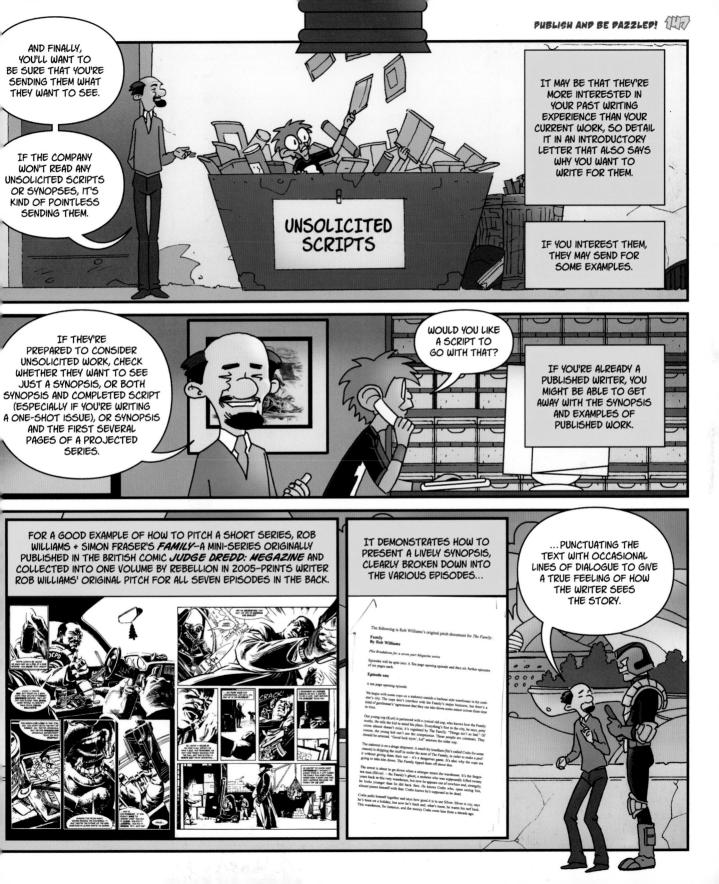

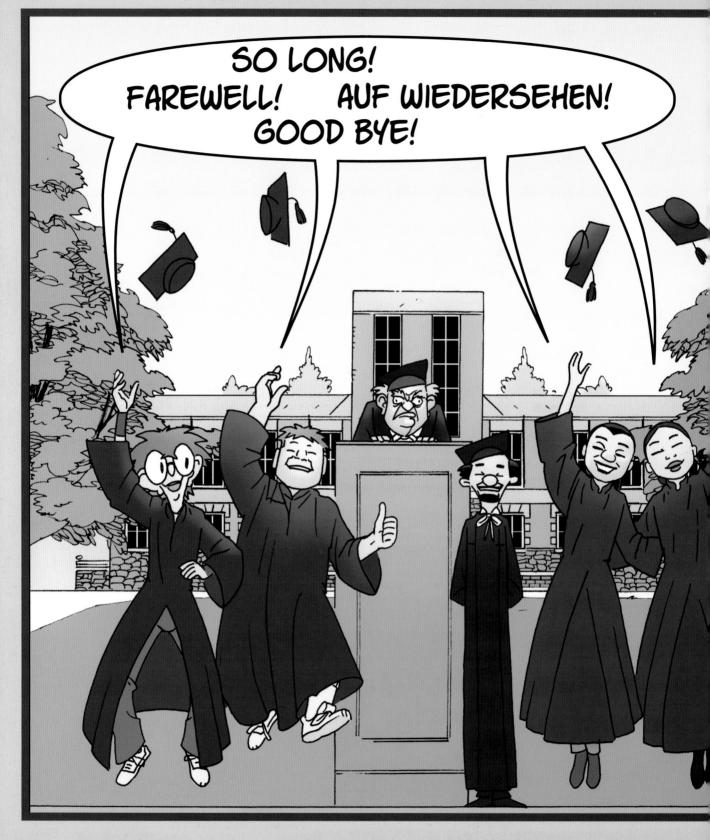

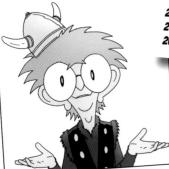

2008-13: DREW ISSUES 1-88 OF LOS BROS 2015: LOS BROS FILM RELEASED BY MIRAMAX 2020: BONGHT A COMIC STORE IN NANTUCKET

Ims

RESOURCES

BOOKS 15	<i>i</i> 0
ORGANIZATIONS + JOURNALS	52
ONLINE RESOURCES	54

2008-PRESENT: LEAD WRITER ON LOS BROS 2015: LOS BROS FILM RELEASED BY MIRAMAX 2016: DISAPPEARED FROM PUBLIC EVE

2010: FOUNDED GLOBALNOV PUBLISHING 2013: BROKERED LOS BROS FILM DEAL 2020: SOLD GLOBALNOV, BOUGHT PLANET

THERE'S AN AWFUL LOT OF READING MATTER AVAILABLE TODAY. GRAPHIC NOVELS, AND THE WHOLE COMICS BUSINESS, ARE NOW JABBING SO HARD AT THE PUBLIC CONSCIOUSNESS THAT PUBLISHERS JUST HAVE TO RESPOND. FROM WILL EISNER'S SEMINAL COMICS AND SEQUENTIAL ART-CONSIDERED BY MANY TO BE ONE OF THE MOST IMPORTANT WORKS ON GRAPHIC NOVELS-TO DEZ SKINN'S COMIX: THE UNDERGROUND REVOLUTION, THERE ARE BOOKS OUT THERE THAT WILL GIVE YOU EVERYTHING FROM THE HISTORY OF COMICS, TO HOW TO DRAW, WRITE, AND SELL THEM.

MARVEL AND DC HAVE PUBLISHED THEIR OWN GUIDES TO CREATING GRAPHIC NOVELS, AND IT'S WORTH TAKING A LOOK AT THEM, EVEN IF YOU NEVER INTEND TO APPROACH THEM. IF THE GUYS WORKING FOR THE WORLD'S BIGGEST COMICS PUBLISHERS DON'T HAVE A FEW GOOD TIPS, THEN WHO DOES? DARK HORSE HAS ALSO PUBLISHED A GUIDE TO WRITING COMIC BOOKS.

YOU'LL FIND THAT THERE ARE ALSO MANY BOOKS BY WRITERS GIVING THEIR VIEWS ON WRITING, AND ARTISTS GIVING THEIR VIEWS ON COMIC ART. YOU CAN EVEN FIND BOOKS ON COMICS TRADITIONS FROM DIFFERENT GEOGRAPHIES AND CULTURES-SUCH AS A. DOUGLAS' **ARAB COMIC STRIPS.** THERE ARE TITLES AVAILABLE ON SPECIFIC SUBJECTS AND STYLES, TOO-SUCH AS MANGA AND ANIMATION, IF YOU'RE INTERESTED.

AND IT MIGHT NOT BE SUCH A BAD IDEA LOOKING UP SOME OF THE MORE GENERAL WRITING GUIDES THAT ARE AVAILABLE, THOSE THAT TELL YOU SIMPLY HOW TO WRITE IN SPECIFIC GENRES. THEY'LL HELP YOU GET A FEEL FOR GENRE EXPECTATIONS, AND ILLUSTRATE HOW TO COME UP WITH A GOOD STORYLINE BEFORE YOU START WORRYING ABOUT BREAKING IT DOWN INTO A SCRIPT! ANZOVIN, STEVE + ANZOVIN, RAF. **3D TOONS.** BARRON'S EDUCATIONAL SERIES, INC 2005

BURROWS, TOBY + STONE, GRANT.

COMICS IN AUSTRALIA AND NEW ZEALAND: THE COLLECTIONS, THE COLLECTORS, THE CREATORS. HAWORTH PRESS INC. U.S. 1994.

CHELSEA, DAVID.

PERSPECTIVE! FOR COMIC BOOK ARTISTS. WATSON-GUPTILL 1997

CHIARELLO, MARK + KLEIN, TODD. THE DC COMICS GUIDE TO LETTERING AND COLORING COMICS. WATSON-GUPTILL 2004

COOPE, KATY.

HOW TO DRAW MANGA. TANGERINE PRESS 2004

DARK HORSE COMICS (VARIOUS CONTRIBUTORS). THE ART OF COMIC-BOOK WRITING. DARK HORSE COMICS. 2002

DOUGLAS, A. + MALTI-DOULGAS, FEDWA.

ARAB COMIC STRIPS: POLITICS OF AN EMERGING MASS CULTURE (ARAB + ISLAMIC STUDIES). INDIANA UNIVERSITY PRESS 1993

EISNER, WILL.

COMICS AND SEQUENTIAL ART. NORTH LIGHT BOOKS 2001 GRAPHIC STORYTELLING AND VISUAL NARRATIVE. NORTH LIGHT BOOKS 2002

FAIGIN, GARY.

THE ARTIST'S COMPLETE GUIDE TO FACIAL EXPRESSION. WATSON-GUPTILL 1990 INES, LURENE,

THE WRITER'S GUIDE TO THE BUSINESS OF COMICS. WATSON-GUPTILL 1998

RTLER, NAT. PANEL ONE: COMIC BOOK SCRIPTS BY TOP WRITERS. ABOUT COMICS 2002 PANEL TWO: COMIC BOOK SCRIPTS BY TOP WRITERS. ABOUT COMICS 2003

AVETT, PAUL.

MANGA: SIXTY YEARS OF JAPANESE COMICS. LAURENCE KING PUBLISHING 2004 GRAPHIC NOVELS: EVERYTHING YOU NEED TO KNOW. COLLINS DESIGN 2005

ARTAS, LEO.

HOW TO DRAW + SELL DIGITAL CARTOONS. BARRON'S EDUCATIONAL SERIES, INC 2004

)GARTH, BURNE

DYNAMIC ANATOMY. WATSON-GUPTILL 2003 DYNAMIC FIGURE DRAWING. WATSON-GUPTILL 1996

INSON, KLAUS.

THE DC COMICS GUIDE TO PENCILING COMICS. WATSON-GUPTILL 2002 THE DC COMICS GUIDE TO INKING COMICS. WATSON-GUPTILL 2003

IBERT, JOE.

SUPERHEROES: JOE KUBERT'S WONDERFUL WORLD OF COMICS. WATSON-GUPTILL 2000

E, STAN + BUSCEMA, JOHN.

HOW TO DRAW COMICS THE "MARVEL" WAY. TITAN BOOKS 1986

ARCHANT, STEVE. THE COMPUTER CARTOON KIT. BARRON'S EDUCATIONAL SERIES, INC, 2006

CCLOUD, SCOTT.

UNDERSTANDING COMICS. HARPER COLLINS 1994 REINVENTING COMICS. HARPER COLLINS 2000.

OORE, ALAN.

WRITING FOR COMICS. AVATAR PRESS 2003 O'NEIL, DENNIS. THE DC COMICS GUIDE TO WRITING COMICS. WATSON-GUPTILL 2001

PILCHER, TIM + BROOKS, BRAD. THE ESSENTIAL GUIDE TO WORLD COMICS. STERLING/COLLINS + BROWN 2005 THE COMPLETE CARTOONING COURSE. BARRON'S EDUCATIONAL SERIES, INC 2001

ROOT, TOM + KARDON, ANDREW. WRITERS ON COMICS SCRIPTWRITING VOL. 2. TITAN BOOKS 2004

SALISBURY, MARK. ARTISTS ON COMICS ART. TITAN BOOKS 2000 WRITERS ON COMICS SCRIPTWRITING. TITAN BOOKS 1999

SKINN, DEZ.

COMIX: THE UNDERGROUND REVOLUTION. THUNDER MOUTH'S PRESS 2004

STARKINGS, RICHARD + ROSHELL, JOHN. COMIC BOOK LETTERING: THE "COMICRAFT" WAY. ACTIVE IMAGES 2003

WILLIAMSON, J.N. HOW TO WRITE TALES OF HORROR, FANTASY AND SCIENCE FICTION. WRITERS DIGEST BOOKS 1987

WITHROW, STEVEN AND BARBER, JOHN. WEBCOMICS BARRON'S EDUCATIONAL SERIES, INC 2005

TWO GREAT WAYS OF KEEPING IN TOUCH WITH TRENDS AND NEWS IN COMICS ARE JOURNALS AND ORGANIZATIONS. SOME OF THE MAJOR PUBLICATIONS ARE COMICS INTERNATIONAL, THE COMICS INTERPRETER, WIZARD, AND THE COMICS JOURNAL.

COMICS INTERNATIONAL CONTAINS NEWS AND REVIEWS, AS WELL AS A COMPREHENSIVE (AND VERY USEFUL) LISTING OF WORLDWIDE COMICS PUBLISHERS. THE COMICS INTERPRETER CONTAINS REVIEWS AND IN-DEPTH ARTICLES ALONGSIDE INTERVIEWS WITH CREATORS IN THE FIELD. WIZARD IS THE BIGGEST MAGAZINE IN THE U.S. THAT COVERS ALL OF THE MORE "MAINSTREAM" SUPERHERO NEWS. THEY ALSO RUN THEIR OWN COMICS CONVENTIONS. THE COMICS JOURNAL IS THE HEAVYWEIGHT, CONTAINING INDUSTRY NEWS, AS WELL AS PROFESSIONAL INTERVIEWS AND THE OBLIGATORY REVIEWS. IF YOU CAN AFFORD IT, GET ALL OF THEM!

THERE AREN'T THAT MANY ORGANIZATIONS THAT DEAL STRICTLY WITH MEMBERS OF THE COMICS TRADE. THE OLDEST ARE THE BRITISH COMICS CREATORS GUILD (WHICH USED TO BE THE SOCIETY OF STRIP ILLUSTRATORS) AND THE GRAPHIC ARTISTS GUILD OF THE U.S.A. BOTH REQUIRE A CERTAIN DEGREE OF PROFESSIONAL EXPERIENCE FROM ANYONE WANTING TO JOIN, AS DOES THE NATIONAL CARTOONISTS SOCIETY.

IN MAINLAND EUROPE THERE IS THE **CENTRO NAZIONALE DEL FUMETTO** (ITALIAN CENTER FOR COMIC ART) THAT, ALTHOUGH BASED IN ITALY, HAS CENTERS IN OTHER EUROPEAN COUNTRIES. THE CENTER MAINTAINS A MASSIVE DATABASE THAT INCLUDES ARCHIVES OF ITALIAN CREATORS AND CHARACTERS, A NATIONAL CONVENTION, AND DAILY NEWS.

FOR BUDDING ARTISTS, THE JOE KUBERT SCHOOL OF CARTOON AND GRAPHIC ART IS WORTH LOOKING INTO. KUBERT IS ONE OF THE OLD MASTERS OF COMIC STORYTELLING, AND HAS BEEN WRITING AND DRAWING THEM FOR OVER 50 YEARS. HIS SCHOOL HAS TAUGHT MANY PROFESSIONAL ARTISTS-INCLUDING HIS TWO SONS, ADAM AND ANDY. THE SCHOOL ALSO RUNS A VARIETY OF CORRESPONDENCE COURSES.

FRIENDS OF LULU IS AN ORGANIZATION PROMOTING THE ROLE OF WOMEN AS BOTH CREATORS AND READERS OF COMICS. THE ORGANIZATION RUNS ITS OWN EVENTS, AND THEIR WEB SITE IS A GREAT RESOURCE.

- JOURNALS -

COMICS INTERNATIONAL

QUALITY COMMUNICATIONS LTD. 345 DITCHLING ROAD, BRIGHTON, BNI 6JJ, UK. WWW.QUALITYCOMMUNICATIONS.CO.UK/CI

THE COMICS INTERPRETER

ABSCESS PRESS (ROBERT YOUNG), 5820 N. MURRAY AVE. D-12, HANAHAN, SOUTH CAROLINA, 29406, USA HTTP://TCI.HOMESTEAD.COM/TCINDEX.HTML

THE COMICS JOURNAL

FANTAGRAPHICS BOOKS, 7563 LAKE CITY WAY NE, SEATTLE, WA98115, USA. WWW.TJC.COM

VIZARD

WIZARD ENTERTAINMENT, 151 WELLS AVE. CONGERS, NY 10920. WWW.WIZARDUNIVERSE.COM

· ORGANIZATIONS -

CENTRO NAZIONALE DEL FUMETTO

CP 3242 UFFICIO POSTALE MARSIGLI, 10100 TORINO, ITALY. WWW.FUMETTI.ORG/CNF

CENTRE NATIONAL DE LA BANDE DESINÉE ET DE L'IMAGE 121, RUE DE BORDEAUX, 16023 ANGOULÉME CEDEX, FRANCE. WWW.CNBDI.FR

COMICS CREATORS GUILD

22 ST JAMES' MANSIONS, WEST END LANE, LONDON, NWG 2AA, UK. WWW.COMICSCREATORS.ORG.UK

FRIENDS OF LULU

550 SOUTH FAIR OAKES AVE. #148, PASADENA, CA 91105, USA. WWW.FRIENDS-LULU.ORG

GRAPHIC ARTISTS GUILD

90 JOHN STREET, SUITE 403, NEW YORK, NY 10038, USA. WWW.GAG.ORG

IOE KUBERT SCHOOL OF CARTOON AND GRAPHIC ART

37B MYRTLE AVENUE, DOVER, NEW JERSEY 07801, USA WWW.KUBERTSWORLD.COM

VATIONAL CARTOONISTS SOCIETY

DAVE COVERLY, MEMBERSHIP CHAIR, PO BOX 8115, ANN ARBOR, MI 48107, USA. WWW.REUBEN.ORG

- FESTIVALS AND CONVENTIONS -

FINLAND

KEMI (MAY): WWW.KEMI.FI/SARJIS

FRANCE

ANGOULÊME (JANUARY): WWW.BDANGOULEME.COM

ITALY

LUCCA (NOVEMBER): WWW.LUCCACOMICSANDGAMES.COM

NORWAY

RAPTUS INTERNATIONAL COMIC FESTIVAL (OCTOBER): WWW.RAPTUS.NO

SPAIN

BARCELONA INTERNATIONAL COMIC FESTIVAL (OCTOBER): WWW.FICOMIC.COM

U.K.

BRIGHTON COMIC EXPO (OCTOBER/NOVEMBER): WWW.COMICEXPO.BIZ BRISTOL INTERNATIONAL COMIC EXPO (MAY): WWW.COMICEXPO.NET CAPTION (AUGUST): WWW.CAPTION.ORG

U.S.A.

APE (APRIL): WWW.COMIC-CON.ORG/APE BIG APPLE CON (SEPTEMBER): WWW.BIGAPPLECON.COM PHILADELPHIA COMIC CON (AUGUST): WWW.PHILADELPHIACOMIC-CON.COM SAN DIEGO COMIC CON (JULY): WWW.COMIC-CON.ORG SPX (SEPTEMBER): WWW.SPXPO.COM WIZARD WORLD: WWW.WIZARDUNIVERSE.COM/CONVENTIONS WONDER CON (MARCH): WWW.COMIC-CON.ORG/WC

EVERYONE SEEMS TO HAVE THEIR OWN WEB SITE THESE DAYS. IT MAKES INITIAL CONTACT A LOT QUICKER, AS WELL AS AIDING IN YOUR RESEARCH AND HELPING YOU OUT WHEN YOU FIND YOUR SOFTWARE ISN'T WORKING QUITE THE WAY IT SHOULD.

ALL MAJOR SOFTWARE DEVELOPERS HAVE THEIR OWN SITES. MOST HAVE HELP LINES OF ONE SORT OR ANOTHER, AND MANY ACTUALLY POST TUTORIALS TO GIVE YOU A HAND WITH THEIR PRODUCT. THERE ARE SITES SPECIFICALLY AIMED AT USERS OF POSER AND BRYCE3D, FOR EXAMPLE, WITH TUTORIALS AND LOTS OF ENCOURAGEMENT FOR BOTH BEGINNERS AND THE EXPERIENCED. THE SAME GOES FOR FLASH, WITH BOTH OFFICIAL AND UNOFFICIAL WEB SITES OFFERING SUPPORT AND ASSORTED TIPS AND TRICKS RANGING FROM ACTIONSCRIPT TO ANIMATION.

YOU CAN ALSO FIND SITES THAT HELP WITH COLORING YOUR ARTWORK-AGAIN WITH TUTORIALS. SOME EVEN PROVIDE BLACK- AND-WHITE ARTWORK FOR YOU TO PRACTICE ON (THOUGH IT'S USUALLY UNDER COPYRIGHT-SO DON'T GO POSTING YOUR FINISHED EFFORTS).

THERE ARE ALSO THE INEVITABLE REVIEW SITES-BUT ALSO SITES HOSTED BY QUITE ESTIMABLE INSTITUTIONS (YALE, FOR INSTANCE), THAT RUN IN-DEPTH ARTICLES ON COMICS AND THEIR HISTORY. YOU'LL ALSO FIND RECOMMENDED READING LISTS (MAINLY FOR LIBRARIES, BUT IT GIVES YOU AN IDEA WHERE YOU SHOULD LOOK), MANGA IMPORTERS AND DISTRIBUTORS, AND-EVEN THOUGH MOST COMICS CREATORS NEVER HIRE AN AGENT-A SITE THAT LISTS AGENCIES WILLING TO TAKE YOU ON. AND DON'T FORGET THOSE ALL-IMPORTANT COMICS PUBLISHERS' WEB SITES!

COMIC RESOURCES -

OK LENGTH WORKS ABOUT COMICS: WWW.COMICSRESEARCH.ORG

DMICLOPEDIA: WWW.LAMBIEK.NET

IROPEAN COMICS RESOURCE SITE: WWW.POEHA.COM/COMICS

EVIEWS SITE: WWW.THEFOURTHRAIL.COM

KIPEDIA - ONLINE ENCYCLOPEDIA: WWW.WIKIPEDIA.ORG

RITERSNET: LINKS TO AGENTS, PUBLISHERS ETC. SPECIFIC TO COMICS FIELD: WWW.WRITERS.NET

LE UNIVERSITY LIBRARY SITE-HUGE RESOURCE CATALOG: WWW.LIBRARY.YALE.EDU/HUMANITIES/MEDIA/COMICS.HTML

ART HELP -

DLORING TUTORIALS: WWW.DAVE-CO.COM/GUTTERZOMBIE

TT BROOKER (D'ISRAELI) SITE, CONTAINS TUTORIALS ON COLORING: WWW.DISRAELI-DEMON.COM

PUBLISHERS -

IRK HORSE WEB SITE: WWW.DARKHORSE.COM

COMICS WEB SITE: WWW.DCCOMICS.COM

ARVEL COMICS WEB SITE: WWW.MARVELCOMICS.COM

DISTRIBUTORS -

AMOND COMICS SITE - DISTRIBUTORS, REVIEWS AND DIRECT SALES: WWW.DIAMONDCOMICS.COM

AALL PRESS COMICS (ONLINE) - SALES, NEWS AND FORUMS: HTTP://SMALLPRESSCOMICS.COM TOKYOPOP - COMPREHENSIVE IMPORTER OF MANGA: WWW.TOKYOPOP.COM/BOOKS/MANGA.PHP

VIZ MEDIA - ANOTHER MAJOR IMPORTER OF MANGA WWW.VIZ.COM

- ONLINE MAGAZINES -

COMIC BOOK RESOURCES - NEWS AND REVIEWS WWW.COMICBOOKRESOURCES.COM

NEWSARAMA - DAILY COMIC BOOK NEWS WWW.NEWSARAMA.COM

SEQUENTIAL TART - COMICS INDUSTRY WEB-ZINE WWW.SEQUENTIALTART.COM

- SOFTWARE -

ADOBE - FOR PHOTOSHOP, ILLUSTRATOR, FLASH, INDESIGN, PAGEMAKER, ETC. SALES AND HELP: WWW.ADOBE.COM

BRYCE 3D SITE: WWW.PETERSHARPE.COM/TUTORIALS.HTM

FLASH TUTORIALS: WWW.NEWTUTORIALS.COM WWW.FLASHKIT.COM/TUTORIALS

POSER TUTORIALS: HTTP://MEMBERS.TRIPOD.COM/~THE_GREAT_SITE/POSERTUT.HTM

- ANTI-ALIASING-THE METHOD USED TO CREATE AN ILLUSION OF A SMOOTH EDGE IN BITMAP IMAGES BY BLURRING THE PIXELS AND FOOLING THE HUMAN EYE.
- **BITMAP**-GRAPHICS IMAGES COMPOSED OF SMALL DOTS (SEE PIXELS) THAT DETERMINE RESOLUTION AND LIMIT THE DEGREE OF ENLARGEMENT THE IMAGE WILL TAKE.
- **BLEED**-RUNNING THE COLORS ON A PAGE RIGHT OFF THE PAGE'S EDGE-AN ALTERNATIVE TO THE USUAL WHITE BORDER.
- **BRIEF**-A SHORT, CONCISE DESCRIPTION OF A CHARACTER GIVING ANY RELEVANT DETAILS THE ARTIST MIGHT NEED TO KNOW TO DEVELOP THAT CHARACTER VISUALLY.
- CMYK MODE-THE COLORS USED IN FOUR-COLOR PRINTING PROCESS: CYAN, MAGENTA, YELLOW, AND BLACK.
- **DPI-**DOTS PER INCH-THE USUAL TERM USED TO DESCRIBE RESOLUTION. MORE ACCURATELY IT SHOULD BE PIXELS PER INCH-PPI.
- FLASH-SOFTWARE USED TO CREATE ANIMATED IMAGES FOR WEBSITES.
- FRAMING DEVICE-A VISUAL WAY OF BRACKETING A PERIOD OF TIME-EITHER AN ENTIRE SCENE OR A SINGLE MOMENT. IT CAN BE USED EITHER TO DRAW THE EYE, OR ISOLATE A SCENE FOR SPECIFIC REASONS.
- GRAYSCALE-IMAGES THAT HAVE VARYING TONES OF GRAY INSTEAD OF FULL COLOR.
- **GUTTER**-THE GAP BETWEEN PANELS-NORMALLY JUST THE WHITE OF UNPRINTED PAPER.
- HTML-HYPERTEXT MARK-UP LANGUAGE-THE CODE USED TO CREATE PAGES FOR THE INTERNET.
- HYPERLINKS -LINKS PLACED WITHIN HTML FILES TO ENABLE INTERNET USERS TO NAVIGATE THEIR WAY BETWEEN AND THROUGH WEB SITES.
- LEVELS-A TOOL FOR ALTERING THE DEGREES OF BLACK AND WHITE (IN GRAYSCALE) OR COLOR IN IMAGES. CAN BE DONE WITH EITHER THE EYEDROPPER TOOL OR THROUGH A SIMPLE CHART.

- LINE ART-BLACK AND WHITE ARTWORK. SHOULD BE SCANNED IN AT HIGHER RESOLUTION THAN GRAYSCALE OR COLOR IMAGES.
- **PANELS**-EACH INDIVIDUAL PICTURE IN A PAGE OF COMIC ART IS A PANEL, USUALLY DELINEATED BY A BLACK OUTLINE AND A GUTTER.
- **PATH-**ANY LINE IN VECTOR SOFTWARE. IT DOESN'T MATTER IF IT'S A STRAIGHT LINE, AN ARC, A COMPLEX CURVE OR CIRCLE.
- PDF-PORTABLE DOCUMENT FORMAT. CAN BE OPENED WITH ADOBE ACROBAT OR READER. ONCE SAVED IN THIS MANNER, THE FILE GENERALLY CANNOT BE EDITED-ONLY READ.
- **PIXEL**-THE SMALL DOTS THAT BITMAP IMAGES ARE CONSTRUCTED FROM.
- **PRIMITIVES**-SIMPLE BASIC SHAPES IN 3D SOFTWARE-SPHERES, CONES, CUBES, ETC. THEY ARE THE BUILDING BLOCKS FOR CREATING 3D SCENES.
- **RENDER**-TERM USED FOR THE ACTION WHEN A 3D SKELETON IS TEXTURED, TO GIVE AN IDEA OF WHAT THE FINISHED IMAGE WILL LOOK LIKE.
- **RESOLUTION**-THE DENSITY OF PIXELS IN AN IMAGE. THE HIGHER THE DENSITY, THE BETTER QUALITY THE IMAGE WILL BE-AND THE LARGER THE FILE SIZE.
- **RGB MODE**-RED, GREEN, AND BLUE-THE PRIMARY COLORS THAT MAKE UP NATURAL LIGHT. USED FOR IMAGES VIEWED ON SCREEN-ALSO SMALLER THAN CMYK FILES.

- SMALL PRESS-TERM USED FOR NON-PROFESSIONAL PUBLISHERS. IT CAN BE MISLEADING AS MANY ARE QUITE LARGE, AND CAN BE ACCORDED AT LEAST SEMI-PROFESSIONAL STATUS.
- TYPOGRAPHY-TERM USED FOR STYLES OF TEXT INCORPORATED INTO ARTWORK-EITHER AS DIALOG, NARRATIVE OR EFFECTS.
- VECTOR SOFTWARE-GRAPHICS SOFTWARE BASED ON LINES RATHER THAN DOTS (SEE BITMAP). VECTOR IMAGES DON'T LOSE QUALITY WHEN THEY ARE ENLARGED.

GE 10, P1 + P5 @ BETTMANN /CORBIS GE 10, PZ. @ COPYRIGHT THE TRUSTEES OF THE BRITISH MUSEUM GE 10, P3. @ VITTORIANO RASTELLI /CORBIS GE 10, P4. SIR JOHN TENNIEL GE 10, P6. CHARLES M SCHULTZ, @ 2005 UNITED FEATURE SYNDICATE, INC GE 11, P1. @ MIKE ESPOSITO GE 11, P2-3, THRILLING PUBLICATIONS GE 11, P4-5. PAGE 15, P6. PAGE 18, P2. PAGE 19, 1-2. PAGE 28, P1. PAGE 29, P1-3. PAGE 37, P2-3. PAGE 41, P2. PAGE 67, P1. PAGE 95, P6. PAGE 107, P3. PAGE 109, P1. ™ + @ 2006 MARVEL CHARACTERS, INC. USED WITH PERMISSION GE 11, P6-7. FROM CONTRACT WITH GOD BY WILL EISNER. COPYRIGHT @ 1978, 1985, 1989, 1995, 1996 BY WILL EISNER. USED BY PERMISSION OF W. W. NORTON + COMPANY, INC. GE 11, P8. DICEBOX (WWW.DICEBOX.NET) © 2005 JENN MANLEY LEE GE 14, PG-7. MAUS II: A SURVIVOR'S TALE AND HERE MY TROUBLES BEGAN 1992 @ ART SPIEGELMAN GE 15, P1-5. RAW MAGAZINE COVERS BY JOOST SWARTE (1.2), GARY PANTER (1.3), CHARLES BURNS (1.4), EVER MEULEN (1.5) AND ROBERT CRUMB (2.3) 1980, 1981, 1982, 1983, 1991 @ RESPECTIVE ARTISTS GE 15, P7-8. PAGE 36, P2. PAGE 37, P4. PAGE 40, P1-2. PAGE 93, P1. PAGE 104, P1. CEREBUS THE AARDVARK @ DAVE SIM AND GERHARD GE 15, P9. PAGE 17, P2. PAGE 96, P2. FRED THE CLOWN @ 2004 ROGER LANGRIDGE GE 15, P10. @ RICH JOHNSTON AND THOMAS NACHLIK GE 15, P11. PAGE 15, P13. @ 1999 LES CARTOONISTES DANGEREUX GE 15, P12. @ 2004 JOHN MCCREA GE 17, P1. @ PAUL GRIST GE 17, P3. PAGE 107, P1. @ 2005 JEFF SMITH GE 18, P1. ALEX RAYMOND © 1937 KINGS FEATURE SYNDICATE GE 18, P3. @ GARRY LEACH AND QUALITY COMMUNICATIONS GE 18, P4. PAGE 38, P1. PAGE 39, P1-2. PAGE 41, P3. PAGE 93, P2, PAGE 107, P2, @ 1991 BRYAN TALBOT GE 18, P5 @ MASH-ROOM CO. LTD. AND KODANSHA LTD. GE 19, PH. COLIN MCNEIL 1990 @ REBELLION A/S GE 20, P1. @ JACK DAVIS GE 20, PZ. @ JOHN BOLTON GE 20, P3. @ JEFF JONES GE 21, P1. @ VAL MAYERIK GE 21, PZ. PAGE 93, P3. @ MIKE MIGNOLA GE 21, P3. @ ERIK WILSON GE 22, P1. @ BERNIE WRIGHTSON GE 22, P2 © JAMES O'BARR 1997, 2003 POCKET BOOKS, KITCHEN SINK GE 22, P3. @ MICHAEL MOORCOCK AND P. CRAIG RUSSEL

PAGE 23, P1. @ 2006 KULL PRODUCTIONS LLC. KULL, KULL OF ATLANTIS, KING KULL, AND RELATED LOGOS, NAMES, CHARACTERS AND DISTINCTIVE LIKENESSES THEREOF ARE TRADEMARKS OF KULL PRODUCTIONS LLC UNLESS OTHERWISE NOTED. ALL RIGHTS RESERVED. PAGE 23, P2. @ LUKE LIEBERMAN PAGE 23, P3. @ MARK SCHULTZ AND THE ESTATE OF EDGAR RICE BURROUGHS PAGE 23, P4. @ WENDY + RICHARD PINI / WARP GRAPHICS, INC PAGE 23, P5. @ HAYAO MIYAZAKI / STUDIO GHIBLI PAGE 24, P3-4. @ 1998 RICHARD PIERS RAYNER AND MAX ALLAN COLLINS PAGE 25, P1. @ JIM STERANKO PAGE 25, P3-4. @ MILO MANARA PAGE 25, P5. © ALAN MOORE AND MELINDA GEBBIE PAGE 26, P1. © TEZUKA PRODUCTIONS PAGE 26, PZ. @ @ 2004 BIRD STUDIO/SHUEISHA, TOEI ANIMATION. LICENSED BY FUNIMATION® PRODUCTIONS, LTD. ALL RIGHTS RESERVED PAGE 27, P1. @ HIROAKI SAMURA AND KODANSHA LTD. PAGE 27, PZ. @ NAOKI URASAWA AND SHOGAKUKAN LTD. PAGE 27, P3. @ AKIMI YOSHIDA AND SHOGAKUKAN LTD. PAGE 27, P4. @ AIT / PLANET LAR PAGE 27, P5. @ BRYAN LEE O'MALLY PAGE 27, PG. @ FRÉDÉRIC BOILET PAGE 28, P2. © JEAN GIRAUD / JEAN-MICHEL CHARLIER, DARGAUD PAGE 28, P3. @ PETER O'DONNELL PAGE 28, P4. HAL FOSTER © 1984 KINGS FEATURE SYNDICATE PAGE 29, PH. @ CLASSIC MEDIA, INC PAGE 30, P2. PAGE 95, P3-5. PAGE 134, P1. © IAN EDGINGTON AND MATT BROOKER PAGE 30, P3. @ MICHAEL MOORCOCK AND WALT SIMONSON PAGE 31, P1. @ JOHN WAGNER AND VINCE LOCKE PAGE 31, P2. PAGE 83, P1. @ BRIAN AZZARELLO AND EDUARDO RISSO PAGE 31, P3. @ FRÉDÉRIC BOILET PAGE 31, P4. @ @ MASH ROOM CO. LTD. AND KODANSHA LTD. PAGE 31, P5. @ JOE SACCO PAGE 31, P6. @ JAIME + GILBERT HERNANDEZ PAGE 34, P1. PAGE 94, P1. @ GEORGE HERRIMAN © 1936 KINGS FEATURE SYNDICATE PAGE 34, PZ. @ 2003 SONG JI-HYOUNG / HAKSAN PUBLISHING CO., LTD PAGE 35, P1. @ RICH JOHNSTON AND THOMAS NACHLIK PAGE 35, P2. @ LES ÉDITIONS ALBERT RENÉ / GOSCINNY-UDÉRZO PAGE 36, P1. @ DAVID LLOYD AND JIM ALEXANDER PAGE 36, P3. @ WARREN ELLIS, PHIL HESTER AND ANDE PARKS PAGE 36, P4. PAGE 92, 3-4. @ 1993 RUBBER BLANKET BY DAVID MAZZUCCHELLI

PAGE 36, PH. @ KILIAN PLUNKETT AND BURLYMAN ENTERTAINMENT INC. PAGE 36, P5. PAGE 63, P1. PAGE 104, P2. © ALAN MOORE AND KEVIN O'NEILL. PAGE 37, P1. @ BRIAN BENDIS AND MICHAEL AVON OEMING PAGE 43, P1. @ JUAN DIAZ CANALES AND JUANJO GUARNIDO / DARGAUD PAGE 69, P1. @ DAVE MCKEAN PAGE 69, PZ. @ AMERICA'S BEST COMICS, LLC PAGE 73, P1. @ DAVID LAPHAM PAGE 74, PI. SCRIPT @ 2004 DAVE GIBBONS PAGE 92, P1. @ ZANZIM AND HUBERT / ÉDITIONS CARABAS PAGE 92, PZ. PAGE 110, P3. @ SERGIO TOPPI / ÉDITIONS MOSQUITO PAGE 93, P4. @ BRENT ANDERSON + BRUCE JONES ASSOC. PAGE 94, PZ. QUARTIER LOINTAIN TZ BY JIRO TANIGUCHI / @ CASTERMAN S.A PAGE 94, P3. @ JOSÉ MUÑOZ AND CARLOS SAMPAYO / CASTERMAN S.A PAGE 94, P4. @ BRIAN BOLLAND PAGE 94, P5. @ CHARLIE ADLARD 2006 REBELLION A/S PAGE 96, P1. @ BOB BURDEN AND CHRIS MCLOUGHLIN PAGE 104, P3. @ BATTAGLIA / ÉDITIONS MOSQUITO PAGE 105, PZ. @ THE ESTATE OF HUGO PRATT / CASTERMAN S.A PAGE 106, P1. @ P. CRAIG RUSSELL AND NEIL GAIMAN. PAGE 108, P1-4. © JM DEMATTEIS AND MIKE PLOOG PAGE 109, P2. @ 2003 DAVE GIBBONS AND BURLYMAN ENTERTAINMENT, INC. PAGE 111, P1. TIME WARP @ ILYA PAGE 128, P1. @ 1990 DAVE GIBBONS AND FRANK MILLER PAGE 142, P1-3. @ GAREN EWING PAGE 147, PI. @ SIMON FRASER 2005 @ REBELLION A/S ALL OTHER ILLUSTRATION @ CHRIS MCLOUGHLIN

ARTISTS 75, 87, 94-5, 126-7, 144-5 ARTWORK 52-3, 54-5, 106-7, 112-13

В

BACKGROUND(S) 128-9 BALLOONS/BOXES 34, 37, 40-1, 65, 97, 102, 118-19 BITMAP/VECTOR SOFTWARE 59, 96-7 BLACK + WHITE 20, 21, 24, 54, 94, 96, 97, 138 BRIEFS 77, 88-9, 100-101

CAMERAS, DIGITAL 68-9 CHARACTER 42-3, 77, 64-5, 80-1, 88, 100, 101, 130-1 CINEMA 4D (MAXON) 124, 125, 128 CMYK (CYAN, MAGENTA, YELLOW, BLACK) 54, 116-17, 138 COLOR 20, 52, 53, 54-5, 95, 105, 116-17 COMIC BOOKS/COMICS 8, 10, 14-15, 26, 30-1, 51, 134-5, 144 CRIME/ADULT 24-5, 31, 73, 83 CROPPING PICTURES 110-11 CYBER-SQUATTERS 46

D

DIALOGUE 40, 42, 43, 51, 64, 65, 78, 147 DIGITAL CAMERAS 68-9 DIGITAL PAINTBRUSHES 54-55 DIGITIZING ARTWORK 53 DRAWING 52-3, 102-3, 126-27 DREAMWEAVER (ADOBE) 59 DRIVERS 98

E EDITORS/EDITING 49, 89, 144, 145 E-MAIL 48, 49, 76, 99, 134

F

FANTASY 11, 22-3, 30, 31, 73, 82, 83 FICTION 16, 22, 31, 64, 82 FILE SIZE 55, 97, 135 FLASH (ADOBE) 136-7 FONTS 35, 97, 119 FORMATTING FILES 56, 57, 59, 96, 138 FRAMES/PANELS 34, 36-7 FRAMING DEVICES 110-111

G

GENRE(S) 16-17, 24-5, 26, 27, 28-9 GRAPHIC NOVELS 8, 10, 11, 14, 30-1 GRAPHICS: CARDS 98; TABLETS 53, 95; TERMS USED FOR 34

H

HARD DRIVE (CAPACITY) 52, 97 HORROR COMICS 20-2, 30, 73, 82 HYPERLINKS 135, 142

IDEAS 62-3, 76, 126, 146 IMAGES: BACKGROUND 129; CGI (COMPUTER GENERATED IMAGES) 124-5 COMPRESSED 57: DIGITAL 96: THREE-D/3D 124; INTERNET (WORLD WIDE WEB) 29, 46-7, 48, 59, 86, 134-5, 139, 142-3

LAYERS 54, 55, 56, 114-15 LAYOUT 51, 58, 102, 108-9 LETTERING 35, 37, 118-19 LIBRARIES 68, 86, 87

М

MAC(5) 49, 58, 98-9 MANGA 18, 23, 26-7, 31, 34 MARKETING/PROMOTION 16, 140-1, 142-3 MEMORY, RANDOM ACCESS (RAM) 52 MONITORS 52, 96, 98, 117 MOOD 104-5 MOVIES 20-1, 24, 63, 84-5

NARRATIVE 34, 35, 37, 38, 41, 42, 43 **NETWORKING 144-5** NOTES/RECORDS, NEED FOR 66-7 NUMBERING PAGES 50, 51, 129

0

ONLINE: COLLABORATING 76-7; SEARCHING 46, 47; SELLING 143; WORKING 48-9

P

PACE 73, 78-9 PANELS 34, 36, 51, 78, 79, 85, 108-9 PC5 49, 98-9 PDF FILES 57, 138 PENCILS 94, 102-3, 113, 120 PHOTOSHOP (ADOBE) 54, 56, 69, 99, 112, 115 PLOTTING STORYLINE 74-5, 79 PRINTERS/PRINTING 30-1, 53, 54, 58-9, 138 PSD FILES 56 PUBLISHERS 15, 16, 17, 46, 47, 58, 140, 144, 146-7 PUBLISHING WORK 58-9, 134-5, 138-9

Ş

AM (RANDOM ACCESS MEMORY) 52 EADERS/VIEWERS 27, 43, 77, 134, 137 ECORDERS 66, 68 ESEARCH 46, 47, 86-7, 128 ESOLUTION 57, 58, 96, 112, 117, 134 GB (RED, GREEN, BLUE) 59, 116-17

5

AVING WORK 52, 56-7, 59, 68 CANNERS 52, 53, 95, 112-13 CIENCE FICTION 18-19, 30, 72, 82 CRIPT(S) 50, 51, 74-5, 102-3, 147 ELF-PUBLISHING 15, 17, 138-9, 140 ELLING ONLINE 139, 142-3 ERVICE PROVIDERS 59 ETTINGS (FOR STORIES) 82-3 HOTS 34, 84, 85, 105, 111, 125, 129 KETCHING 67, 76, 126-7 OFTWARE: BACKGROUNDS 128; BITMAPS + VECTORS 59, 96-7; CHARACTER 130, 131; COLOR 54; FOR DRAWING 52-3; IMAGES 69; ONLINE 49; PDF FILES 57; THREE-D/3D 124, 125, 128, 130; WEB SITES 59; WORD PROCESSING 56 OUND 34, 35, 40, 120, 135, 136-7 PEECH 34, 35, 37, 40, 42, 65, 102 TORY STRUCTURE 38-9, 72, 74-5, 79, STORYLINE 38-9, 42, 72, 89 TYLE(S) 72-3, 92-3, 106-7 UPERHEROES 18, 19, 21, 30, 83 YNOPSES 88-9, 147

T

TERMINOLOGY (GRAPHICS) 34-5 TEXT: PRESENTING 50-1; SAVING 57; WORD PROCESSING 49, 56 THREE-D/3D 124, 125, 128, 130 TIFF (TAGGED IMAGE FILE FORMAT) 56, 58, 138 TV 20, 41, 63, 124 TYPE/TYPOGRAPHY 35, 41, 120-1

ľ

VIDEO: GAMES 63; RECORDERS 68 VIRUSES 99

W

WEB (WORLD WIDE) 46-7, 58-9, 142 WEB COMICS 134-5 WEB SITES 59, 134, 135, 142-3, 146 WEB-RINGS 143 WORD(S): CRUNCHING 50; PROCESSING 56 WORKING METHODS 48-9, 74-5, 100, 102 WRITING: BRIEFS 88-9; SCRIPTS 74-5 WRITING STYLES 72-3

MIKE CHINN WOULD LIKE TO THANK BILL MCLOUGHLIN, BILL GRAHAM, MARTIN LINDSAY AND EUAN KERR: FOR INTRODUCING ME TO THE GAME-AND FOR STILL LETTING ME COME BACK AND PLAY OCCASIONALLY.

> CHRIS MCLOUGHLIN WOULD LIKE TO THANK GWEN, NOLWENN AND PETER FOR THEIR HELP, AND DAVID ROACH FOR HELPING TO FIND THE RIGHT PICTURES TO FIT THE SPACES.